American Folk Art

at the Shelburne Museum

By Henry Joyce and Sloane Stephens

Research Assistants
Sarah Chasse and Meredith Scott

Shelburne Museum
Shelburne, Vermont

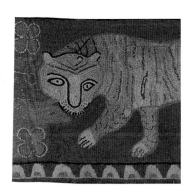

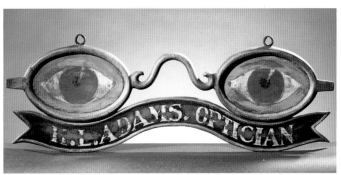

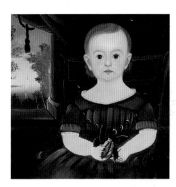

Cover: *Fruit on Marble.* Artist unknown, about 1850.

ISBN: 0-939384-26-4

Photographs by Sanders H. Milens on pages: cover, 2, 3, 4, 5, 6, 9, 10, 12, 14, 15, 19, 22, 23, 25, 26, 29, 31, 33, 34, 35, 40, 42, 43, 45, 52, 53, 56, 58, 59, 63, 64, 65, 66, 68, 69, 73, 80, 87, 88. Photographs by Ken Burris on pages: title page, 11, 16, 19, 20, 21, 24, 26, 27, 28, 29, 30, 36, 38, 39, 41, 46, 47, 48, 49, 51, 54, 57, 60, 61, 64, 66, 67, 68, 70, 71, 72, 73, 74, 75, 76, 77, 78, 79, 82, 83, 84, 85, 86, 87, 89. Photographs by Mark Sasahara on pages: 54, 55, 90.

Graphic Design
Vicky McCafferty

Printed By
Transcontinental Printing, Montreal, Canada

Published By
Shelburne Museum
U.S. Route 7, P.O. Box 10, Shelburne, Vermont 05482

Contents

This publication was made possible with a generous grant
from the Henry Luce Foundation.

Acknowledgements

Grateful acknowledgement is made to all who helped make this publication possible,
particularly Celia Y. Oliver, Curator of Textiles, for her contributions on quilts and rugs;
Polly Darnell, Archivist, for her research and editing; and Julie Yankowsky, Rights and
Reproductions Manager, for her image research and coordination of photography. Thanks
to the institutions who permitted our reproduction of their works. Deepest appreciation is
extended to the Henry Luce Foundation Inc. for its generous support of the research on
the folk art collection and the reinstallation of the folk art galleries
at the Shelburne Museum in 2002.

Electra Havemeyer Webb

1888-1960

Museum founder, collector, and visionary.

"After you have been collecting for a number of years, you give thought as to what you are going to do with your collections... I felt that I wanted to return to the country the objects that had given me so much pleasure and hope that others enjoy them as much as I did collecting them." September 1, 1960

Shelburne Museum Founder Electra Havemeyer Webb, Collector of Folk Art

One of the nation's premier collections of American folk art is housed at the Shelburne Museum in Shelburne, Vermont. The museum was founded by Electra Havemeyer Webb (1888-1960), who collected folk art even before it was recognized as such by scholars or the general public. Mrs. Webb inherited her love for art from her parents, Henry O. and Louisine Havemeyer, who were among the most distinguished American collectors of French Impressionist paintings. Electra pursued her own taste, however. When, at nineteen, Electra Havemeyer brought home her first folk art object — a tobacco store figure (see photo) she saw on a sidewalk in Stamford, Connecticut — she was met with her mother's disapproval. "If you could have seen my mother's face! She said, 'What have you done?' And I said, 'I bought a work of art.'"

Soon after her 1910 marriage to James Watson Webb (1884-1960), son of Dr. William Seward Webb and Lila Vanderbilt Webb, the new Mrs. Webb began to remodel an old farm house, The Brick House, located in Shelburne at her husband's family estate, Shelburne Farms. She filled it with her ever-growing collections of American folk art, antique furniture, ceramics, glass, pewter, quilts and hooked rugs. Beginning in 1921 with the purchase of another old farm house at Westbury, New York, Mrs. Webb undertook to remodel this second house and also to fill it with her collections until she sold the Westbury house in 1949 and moved more permanently to Vermont.

Mrs. Webb had been collecting for forty years when she founded the Shelburne Museum in 1947. Today, the museum's folk art collection includes over four thousand objects. At the Shelburne Museum, the term "folk art" describes a diverse group of objects (including paintings, decoys, painted furniture, quilts, ships' carvings, cigar store figures, trade signs, weather vanes and whirligigs), mostly from the 18th and 19th centuries. These predominantly utilitarian pieces were usually made outside of the prevailing conventions of fine art and were first considered art — and therefore collectable — about a hundred years ago.

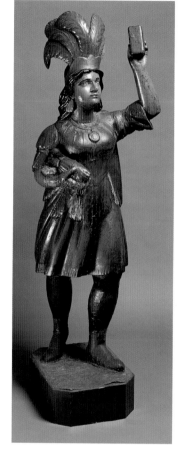

Mary O'Connor
Cigar store figure
Maker unknown
19th century
Carved and painted wood
H. 64"; W. 21"; D. 20"
Purchased from the estate of
J. Watson Webb, Jr., 2000
2000-24.1

Nineteen-year-old Electra Havemeyer bought this figure in 1907 (three years before she married J. Watson Webb) from a store in Stamford, Connecticut, near where her parents had a summer house. It was the first folk art sculpture she bought, at a time when there were very few collectors of Americana. A few years before her death in 1960, Electra Webb described how as a teenager she wanted to own art that was very different from the European paintings that her parents and their friends collected. Her buying of the figure is clear evidence of the antiquarian character of her collecting; she liked a wide range of old things that evoked for her the American past.

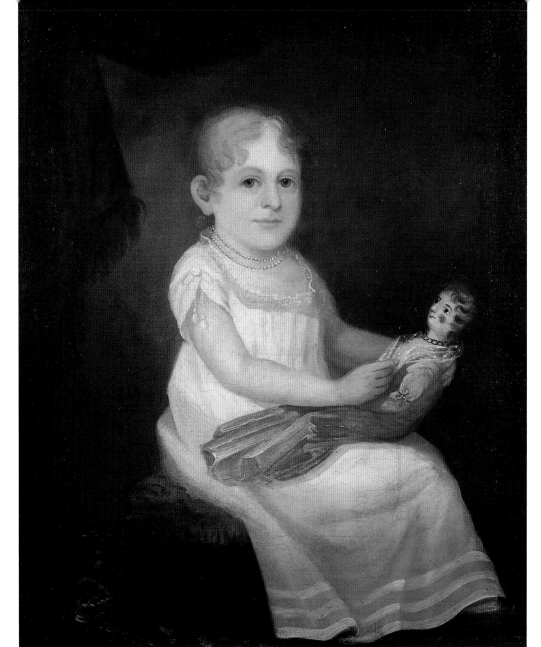

Sarah Ann Tompkins

(1805-1845)

Ezra Ames (1768-1836)

About 1809

Oil on canvas

H. 31 1/2"; W. 25"

Purchased from Edith Halpert,

Downtown Gallery, 1953

27.1.1-12

Four-year-old Sarah Ann holds what is probably an expensive English doll. Most American children in the early 19th century did not own such toys, but Sarah Ann was the daughter of Daniel D. Tompkins, the fourth governor of New York State (1817-1825), who was able to afford such a costly plaything for his daughter.

Ezra Ames (1768-1836), a portrait, landscape, and sign painter, was born in Framingham, Massachusetts. He spent most of his life in Albany, New York, where he probably painted this portrait. The artist painted nearly five hundred recorded works and was also a prominent Mason and banker.

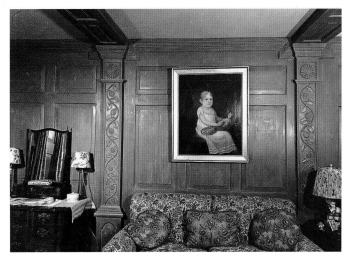

The Brick House, mid 1950s, with the portrait of Sarah Ann Tompkins hanging in a bedroom. Shelburne Museum Archives (PS 3/5 10).

Donkey
Maker unknown
19th century
Carved and painted wood
H. 41"
Purchased by Electra Havemeyer
Webb from Helen Bruce,
before 1938
FM-46

In a 1938 photograph of Mrs. Webb's Shelburne, Vermont, home, The Brick House, this donkey is shown under the stairs of the front hall, where it stands today.

Helen Bruce, from whom Mrs. Webb bought the donkey, owned an antique shop in New York City. The two women became friendly, and in the 1950s, Mrs. Webb created the Bruce Room in the museum's Hat and Fragrance Textile Gallery to exhibit her friend's dollhouse rooms.

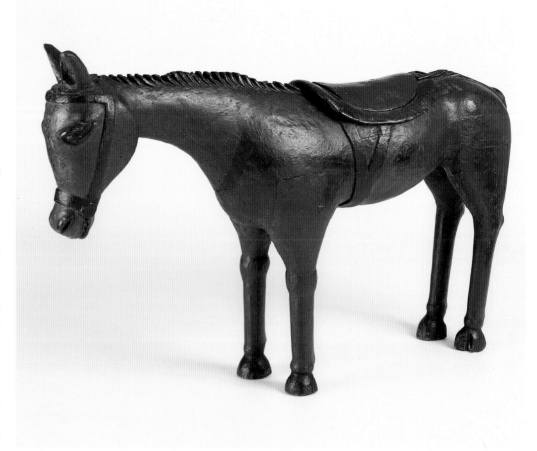

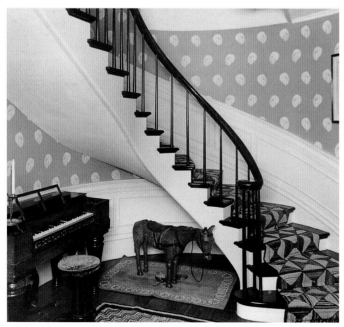

The Brick House, front staircase, 1938 . Shelburne Museum Archives (PS 3/11 S1938 p27).

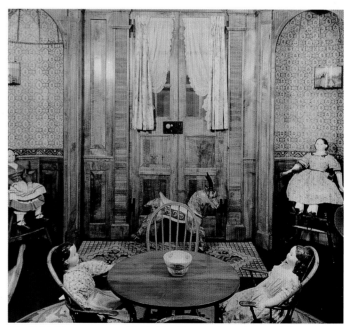

The Brick House, room with Hobby Goat and two Bruce vitrines on wall, 1938. Shelburne Museum Archives (PS 3/11 S1938 p75).

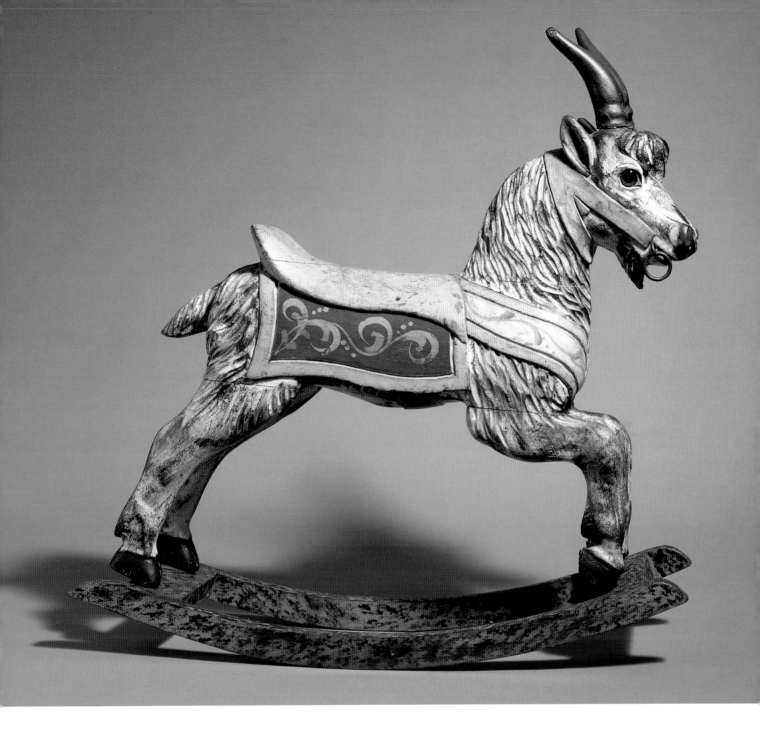

Hobby Goat

Maker unknown

European

19th century

Carved and painted wood

H. 28"; W. 30"; D. 8"

Purchased by Electra Havemeyer

Webb from Helena Penrose,

before 1938

FM-8

When Mrs. Webb purchased *Hobby Goat* it was thought to have been made in America, but today it is believed to be of European origin, probably made for a carousel.

Hobby Goat appears in a 1938 photo of Mrs. Webb's home in Shelburne, Vermont, The Brick House (now the property of the Shelburne Museum). In the photo, it shares the space with other children's toys and furniture. Before founding the museum in 1947, Mrs. Webb sometimes experimented with installation ideas at The Brick House, often incorporating folk art like *Hobby Goat* within museum-like settings.

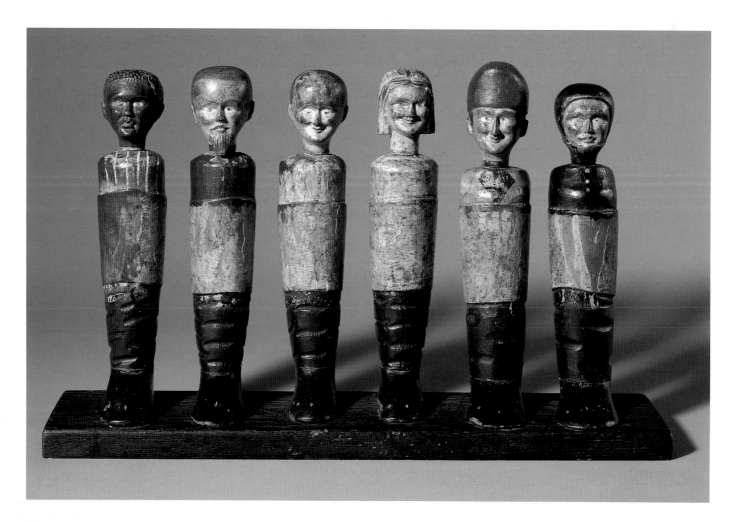

Nine Pins

Maker unknown

19th century

Carved and painted wood

H. 12 1/4"; W. 19"; D. 4 3/4"

Purchased by Electra Havemeyer
Webb from Edith Halpert,
Downtown Gallery, 1941

FM-6

These six figures in medieval style clothes are from a set of nine pins, an indoor bowling game popular in 19th century Europe and America. In the 1930s when folk art collecting was still new, *Nine Pins* became a celebrated sculpture. In 1931 the piece was included in the first folk art exhibition ever held at an American art museum, at the Newark Museum in New Jersey. *Nine Pins* was also recorded in a 1937 watercolor for the Index of American Design.

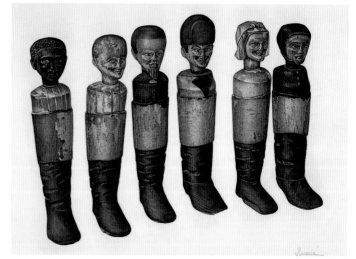

Index of American Design watercolor of Nine Pins, 1937. Photograph ©2001 Board of Trustees, National Gallery of Art, Washington.

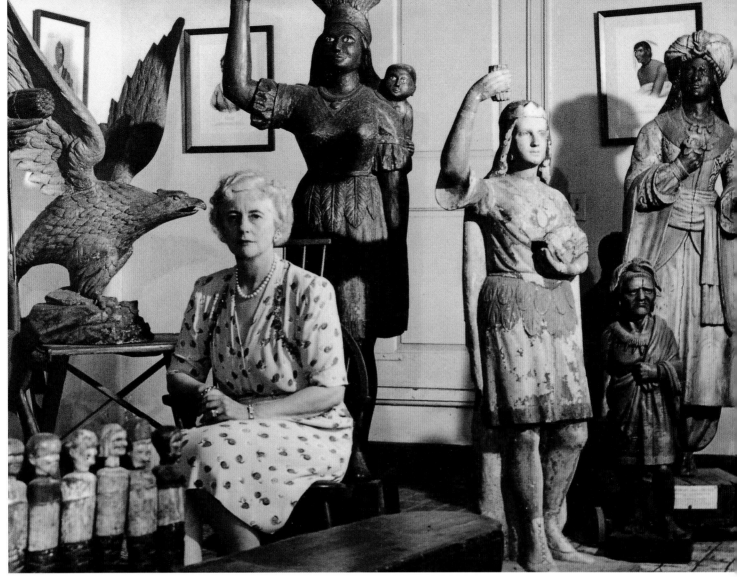

Electra Havemeyer Webb with her collection of folk art sculpture at her home in Westbury, New York, 1946. Photograph courtesy of TIME/ LIFE Syndication.

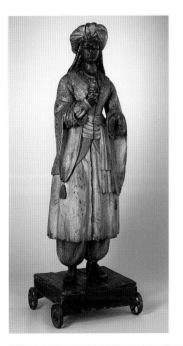

Turkish Girl

Cigar Store figure

Maker unknown

About 1850

Carved and painted wood

H: 61"

Purchased by Electra Havemeyer

Webb from Edith Halpert, Downtown

Gallery, 1941

FT-18

Turkish Girl appears in this 1946 photograph of Electra Havemeyer Webb's collection at her Westbury, New York, house. This sculpture was included in the federal government's Works Progress Administration's Index of American Design, a project that recorded for posterity the very best examples of American design.

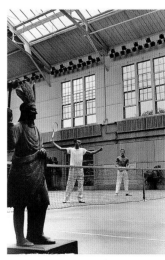

Mrs. Webb used the family's indoor tennis court to exhibit her ever growing collection of folk art. June 1946, Nina Leen, Time Pix.

Edith Halpert and the Downtown Gallery

By the 1940s, Electra Webb was a regular customer at the Downtown Gallery in New York City. Its owner, Edith Halpert, was an influential dealer in both contemporary American art and folk art; she played a central role in the establishment of folk painting and sculpture as a distinct category of art. Edith Halpert became a friend of Mrs. Webb and, later, a member of the board of trustees of the Shelburne Museum. She worked closely with the Index of American Design, a Works Progress Administration program set up in 1935 to create a permanent record of outstanding examples of American design and craftsmanship. Downtown Gallery's American Folk Art Gallery was the source for many of the Shelburne Museum's finest folk art pieces and the site of the 1950 exhibition "A Museum Collection," which included some of the first folk sculpture to be brought to the museum.

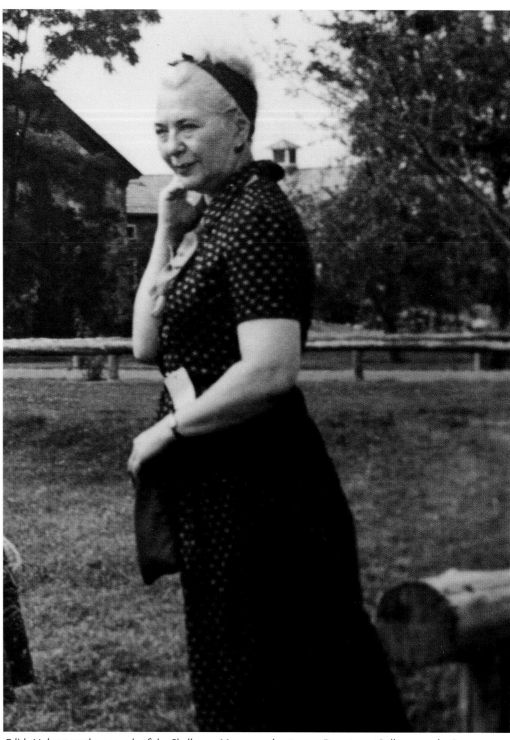

Edith Halpert on the grounds of the Shelburne Museum, about 1955. Downtown Gallery records 1824-1974, Archives of American Art, Smithsonian Institution.

Liberty

Carved by Eliodoro Patete of
Anawalt, West Virginia
Inscribed bottom center: "Made by
Eliodoro Patete of Vastogirardi,
Italy, in Anawalt, WV after 1863"
Carved and painted wood
H. 36"
Purchased from Edith Halpert,
Downtown Gallery, 1954
FM-70

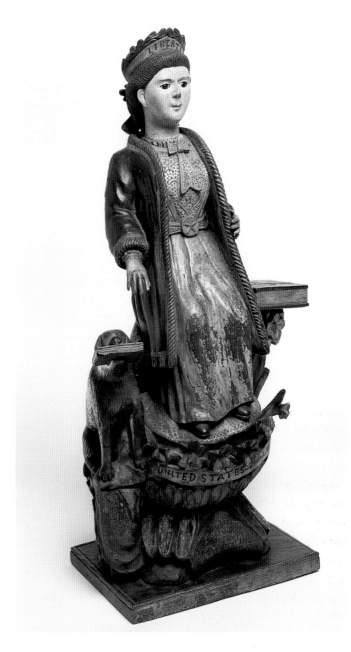

This is the only folk sculpture at the museum that bears its maker's inscription and date, a rare instance in 19th century folk art.

In the 1930s, *Liberty* was owned by Juliana Force, founding director of the Whitney Museum of American Art. It was later purchased by Elie Nadelman, the modernist American sculptor and folk art museum founder. *Liberty* was considered a work of notable artistic merit, but Edith Halpert, from whom Mrs. Webb bought the sculpture, preferred "highly simplified objects" and seemed not to have liked *Liberty*. Because *Liberty* was "considered one of the most celebrated American sculptures," however, she recommended it to the Shelburne Museum to "add self confidence to the collection."

Detail of Liberty

All the folk art objects that Electra Webb purchased from the prominent dealer Edith Halpert became part of the museum's collection. The photograph on the opposite page shows works exhibited at the Downtown Gallery in New York before they were shipped to the Shelburne Museum in 1950.

Mrs. Halpert began selling folk art in 1929 and established a reputation for searching out fine quality pieces for private and museum collections. The press release for her 1950 show of works bound for the Shelburne Museum stated that the collection "comprises a group of important sculpture in wood and metal... In line with the established policy of the gallery, the emphasis in this exhibition of folk art is on aesthetic quality rather than historical significance, antiquity or nostalgic association." Both *George Washington on Horseback* and *Angel Gabriel* appear in the exhibition photograph.

*George Washington
on Horseback*

Maker unknown

Early 19th century

Carved and painted wood, leather
and brass

H. 23"; W. 22"; D. 7"

Purchased by Electra Havemeyer
Webb from Edith Halpert,
Downtown Gallery, and antiques
dealer Mary Allis, 1943

FM-3

When Mrs. Webb purchased this piece in 1943, Edith Halpert wrote that it was "one of the most important sculptures discovered in the folk art tradition." Today, it continues to be one of the most widely known and highly regarded, and rarest, examples of early 19th century folk sculpture.

It was probably inspired by a print after Thomas Sully's 1819 oil portrait of George Washington (see illustration). Its anonymous maker has transformed the classical convention of equestrian portraiture into a splendid miniature carving.

In the 1940s Mrs. Halpert suggested that *George Washington on Horseback* was made in the 18th century, but its dependence on the Sully image suggests a more likely date of the 1820s.

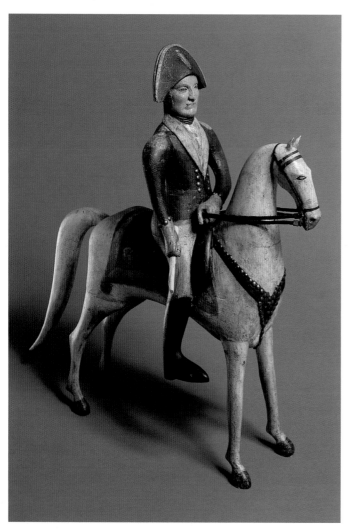

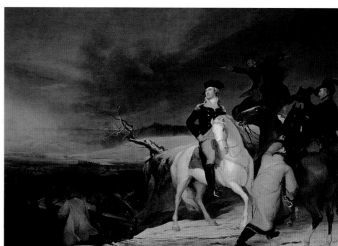

The Passage of the Delaware, *Thomas Sully, 1819. Courtesy, Museum of Fine Arts, Boston. Reproduced with permission. ©2000 Museum of Fine Arts, Boston. All rights reserved.*

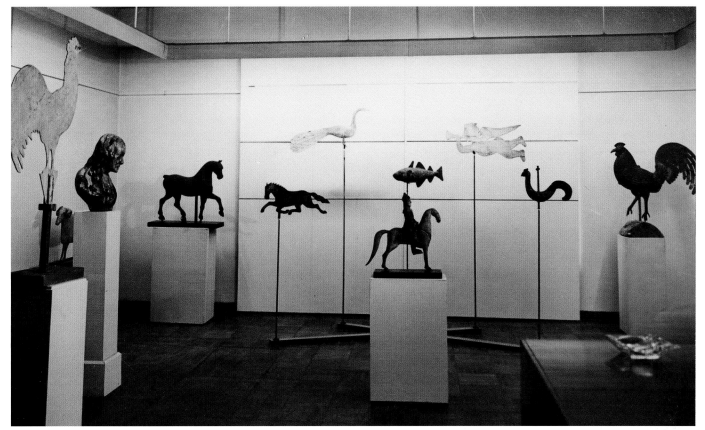

View of the exhibition "Museum Collection," Downtown Gallery, New York City, 1950. Downtown Gallery records 1824-1974, Archives of American Art, Smithsonian Institution.

Angel Gabriel

Weather vane

Maker unknown

19th century

Carved and painted wood

H. 13"; W. 33 1/2"; D. 1/2"

Purchased from Edith Halpert,

Downtown Gallery, 1950

FW-2

Gabriel, one of the seven archangels of the Old Testament, was sent to earth as a herald of comfort and good tidings. Weather vane figures of Gabriel blowing his trumpet were once seen atop many New England churches.

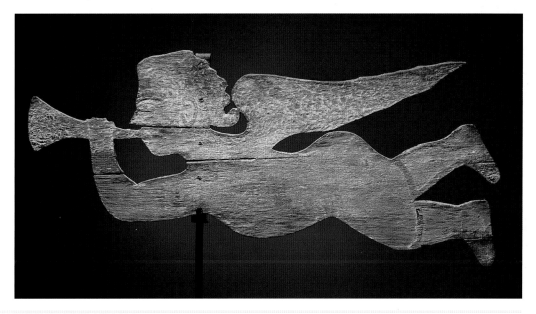

Founding the Shelburne Museum

Electra Havemeyer Webb is the only woman in America to create a large art and outdoor history museum. By the time of its founding in 1947 she had been collecting for forty years. From then until her death thirteen years later in 1960, Mrs. Webb collected even more avidly. To house her collections she purchased or was given over twenty-five late 18th and early 19th century buildings, which she then moved to the museum.

The photograph shows the ballroom of the museum's Stagecoach Inn, about 1955. The collection was arranged by Mrs. Webb and Edith Halpert as a three dimensional composition of shapes against a red wall. This kind of grouping reflects Mrs. Halpert's interest in a modernist aesthetic where the juxtaposition of silhouettes becomes the dominant visual effect. This aesthetic is also apparent in the photograph on the previous page which shows the museum's collection on exhibition at Mrs. Halpert's Downtown Gallery in 1950.

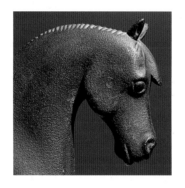

Formal Horse
Weather vane
Manufacturer unknown
19th century
Cast iron, sheet iron tail missing
H. 29"; W. 25"
Purchased from Edith Halpert,
Downtown Gallery, 1950
FW-11

*Stagecoach Inn,
ballroom, about 1955*

An almost identical cast iron horse was included in one of the first folk art exhibitions in an American museum, at New Jersey's Newark Museum in 1931. In the show, the piece was described as *Formal Horse,* the name that still is used for several related examples, including this one. The 1931 exhibition catalog describes the sculpture as "gaining dignity by the formality of his pose" and "an outstanding figure with strong sculptural feeling." *Formal Horse* was also compared to "the work of [the] Chinese"; the writer probably was thinking of Tang dynasty (618-906 A.D.) ceramic sculpture, which was beginning to be collected in the United States.

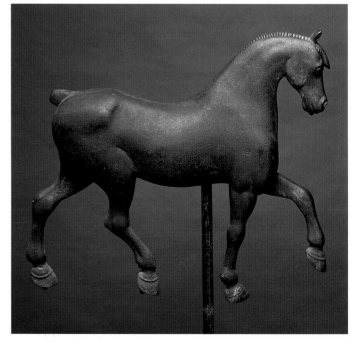

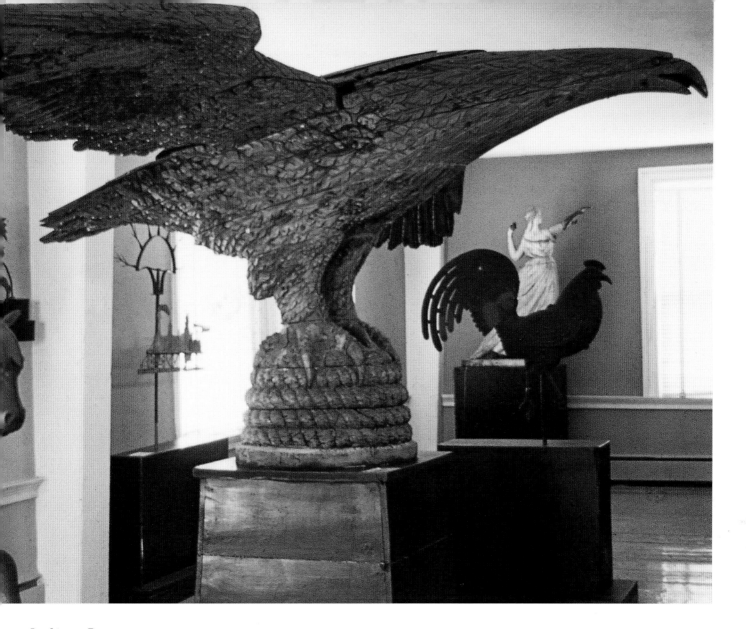

Indian Bust

Head and shoulders fragment of a
tobacconist figure

Samuel Robb's workshop

New York City

Late 19th century

Carved and painted wood

H. 28"

Purchased by Electra Havemeyer

Webb from Edith Halpert,

Downtown Gallery, 1941

FT-1

In 1941 this sculpture was featured in the window of
Edith Halpert's Downtown Gallery on East 51st Street in
New York City, advertising her exhibition, "Masterpieces in
American Folk Art." From the show, Electra Havemeyer
Webb purchased this piece, *TOTE* (page 24), and
Revolutionary Soldier (page 26). Mrs. Webb went on to pur-
chase over one hundred other folk art objects from the
Downtown Gallery, until her death in 1960.

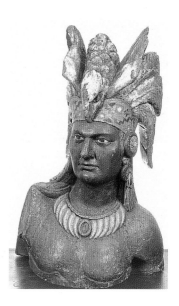

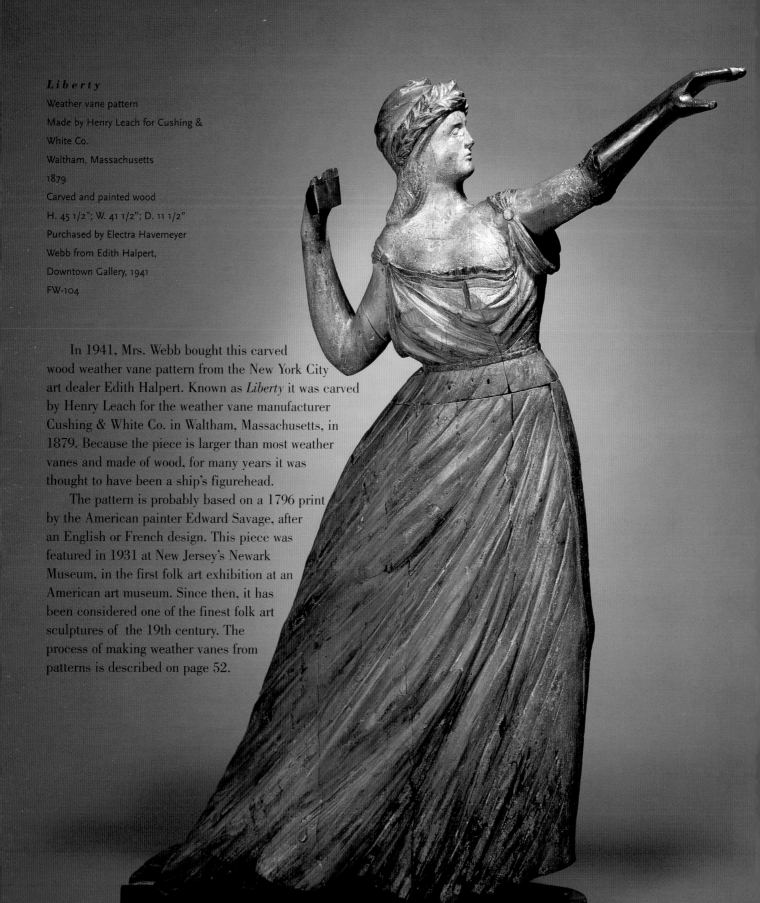

Liberty
Weather vane pattern
Made by Henry Leach for Cushing &
White Co.
Waltham, Massachusetts
1879
Carved and painted wood
H. 45 1/2"; W. 41 1/2"; D. 11 1/2"
Purchased by Electra Havemeyer
Webb from Edith Halpert,
Downtown Gallery, 1941
FW-104

In 1941, Mrs. Webb bought this carved
wood weather vane pattern from the New York City
art dealer Edith Halpert. Known as *Liberty* it was carved
by Henry Leach for the weather vane manufacturer
Cushing & White Co. in Waltham, Massachusetts, in
1879. Because the piece is larger than most weather
vanes and made of wood, for many years it was
thought to have been a ship's figurehead.

The pattern is probably based on a 1796 print
by the American painter Edward Savage, after
an English or French design. This piece was
featured in 1931 at New Jersey's Newark
Museum, in the first folk art exhibition at an
American art museum. Since then, it has
been considered one of the finest folk art
sculptures of the 19th century. The
process of making weather vanes from
patterns is described on page 52.

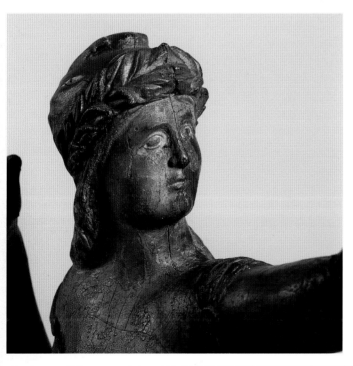

Liberty *weather vane made from molds cast from Shelburne Museum's pattern. Private collection.*

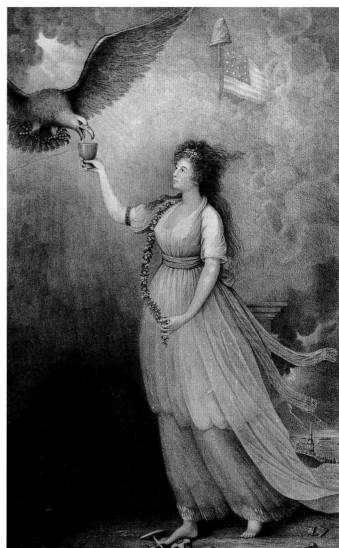

Liberty in the form of the Goddess of Youth: Giving Support to the Bald Eagle. *Edward Savage, 1796. New York State Historical Association, Cooperstown, NY.*

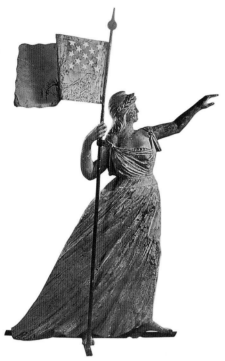

Detail of the weather vane pattern Liberty.

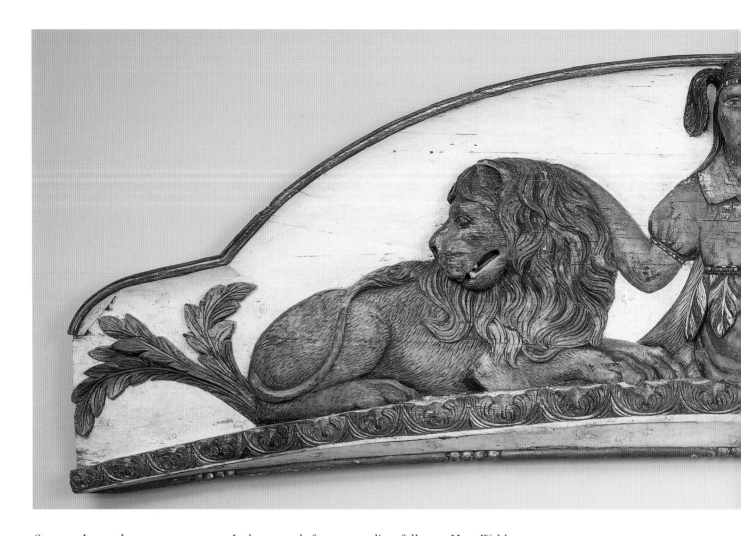

Stern board

Maker unknown

Late 18th or early 19th century

Carved and painted wood

H. 39"; W. 117 1/2"; D. 7 1/4"

Purchased from Edith Halpert,

Downtown Gallery, 1951

FS-13

In her search for outstanding folk art, Mrs. Webb purchased a select group of ship carvings including this stern board, which is probably the best in the collection. It has recently been cleaned to reveal the lively, clear colors that had been obscured by dark over-painting, varnish, and dirt.

The Native American figure, symbolizing America, sits between a tamed lion, representing defeated England, and a deer killed by an arrow, a symbol — especially in the early Republic — of American freedom. (In Europe only the aristocracy could freely hunt deer.)

The photograph on the right, taken at the Shelburne Museum about 1955, shows one of the whimsical folk art installations for which Mrs. Webb was renowned — a composition of diverse objects, including the stern board. The grouping includes a Canadian chest, two cigar store figures, a fish weather vane, a carved wooden eagle, and a rooster weather vane. Mrs. Webb worked to create innovative gallery settings like this one in order to delight museum visitors and flatter the works of art.

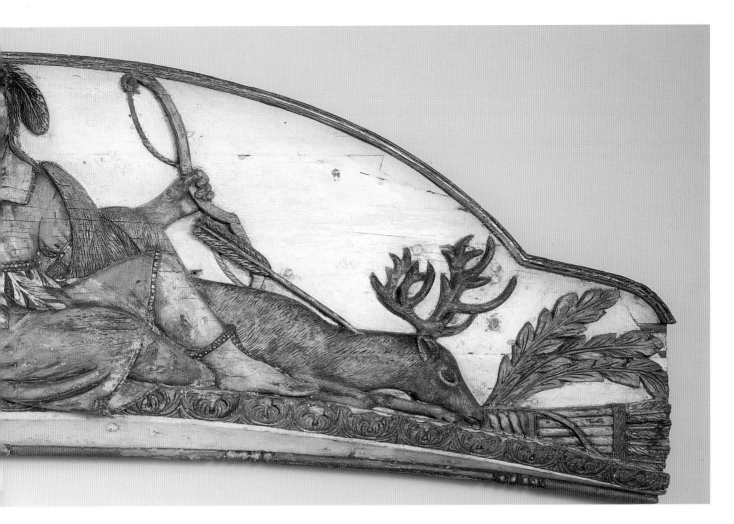

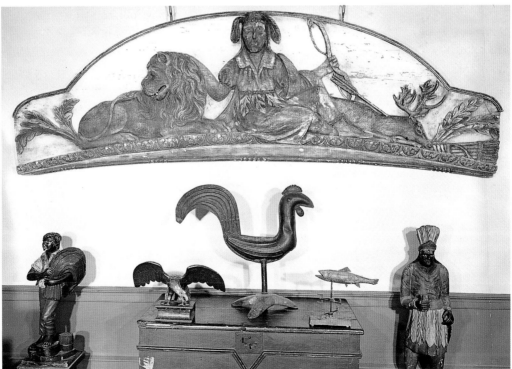

Stagecoach Inn Installation, Shelburne Museum, about 1955.

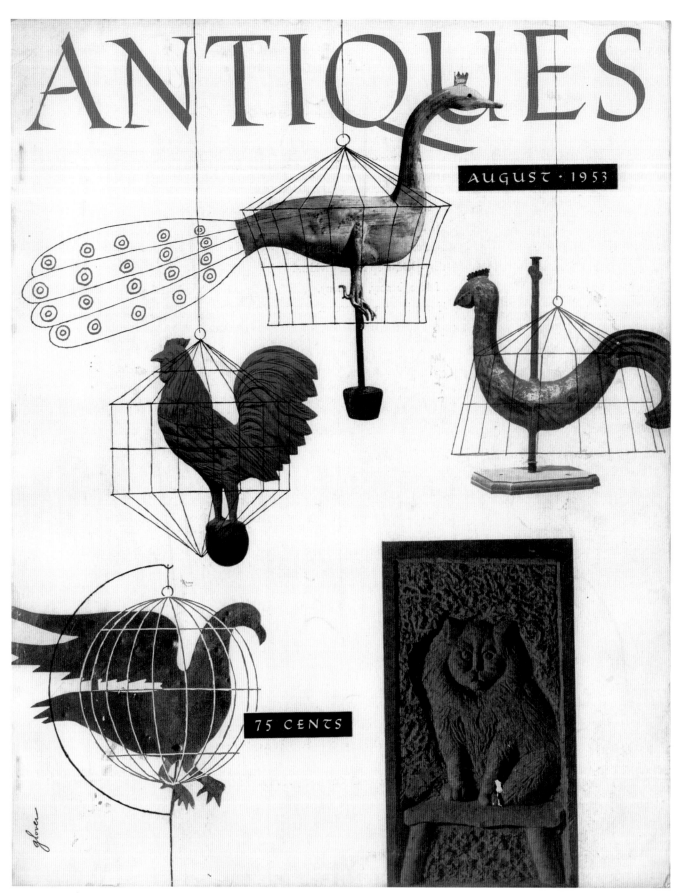

August 1953 The Magazine ANTIQUES *cover. Courtesy of* The Magazine ANTIQUES.

These five works were featured on the August 1953 cover of *The Magazine ANTIQUES*. The cover artist created a fanciful drawing of cages around the bird weather vanes. Founded in 1922, the magazine had originally been dedicated to American decorative and fine arts but added articles on folk art as more people began to value and collect it. In this 1953 issue, Alice Winchester, editor, referred to these pieces as "country antiques" and wrote, "The motifs of our cover design are provided by unusual examples of American folk sculpture... These fascinating creatures are but a few from the remarkable collection of folk sculpture in the Shelburne Museum... They also deserve respect, as eloquent symbols of our heritage, and as honest and honorable products of the creative spirit."

Peacock
Weather vane
Attributed to L. W. Cushings & Sons
Waltham, Massachusetts
Late 19th or early 20th century
Copper and lead
H. 16"; W. 36 1/2"
Purchased from Edith Halpert,
Downtown Gallery, 1950
FW-17

Fighting Cock
Weather vane
Maker unknown
19th century
Carved and painted wood, metal
H. 30"; W. 21 1/2"; D. 5/12"
Purchased from Edith Halpert,
Downtown Gallery, early 1950s
FW-27

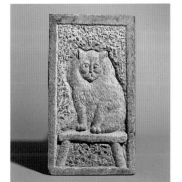

Gravestone for Cat
Maker unknown
19th century
Carved soapstone
H. 23"; W. 13 1/2"; D. 2"
Purchased from Edith Halpert,
Downtown Gallery, 1951
FM-39

Eagle
Weather vane
Maker unknown
19th century
Sheet iron
H. 17 1/2"; W. 24 1/2"; D. 1/4"
Purchased from Edith Halpert,
Downtown Gallery, 1952
FW-45

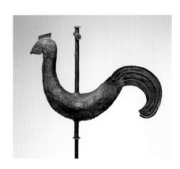

Rooster
Weather vane
Maker unknown
19th century
Metal
H. 14 1/2"; W. 18 1/4"; D. 2 1/4"
Purchased from Edith Halpert,
Downtown Gallery, early 1950s
FW-18

Harvard Chest

Maker unknown

Essex County, Massachusetts

1700-1725

Painted wood

H. 44 1/4"; W. 38 1/2"; D. 21"

Gift of Katharine Prentis Murphy,
1956

1956-694.8; 3.4-2

During the 19th century a rare group of chests, including this one, decorated with red buildings, were sometimes called Harvard chests because the painted images were thought (mistakenly) to be of the brick buildings at that university.

The colored motifs, painted on a black ground, simulate the expensive lacquer furniture from Asia that was fashionable at this time. The western technique is known as "japanning." This chest is part of a small but impressive group of furniture that was probably made in the Boston area, where, by the early 18th century, more than a dozen craftsmen in "japanned" furniture were active.

Katharine Prentis Murphy, who gave the chest to the Shelburne Museum, was a dear friend of Electra Webb, and a much respected collector in her own right. She gave the museum over a hundred objects to furnish an 18th century Massachusetts house. Mrs. Webb moved the house to the museum specifically to hold her friend's generous donation and named it for her — Prentis House.

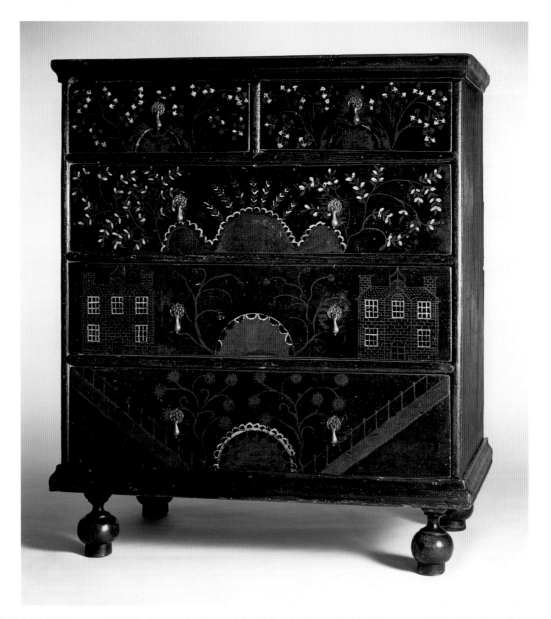

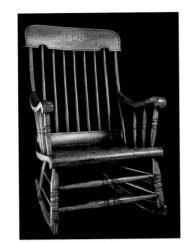

Rocking Chair

Trade sign

Maker unknown

1849

Painted wood

H. 77"; W. 45 1/4"; D. 36"

Purchased from C.H. Kelley, 1957

FT-82

Atop its roof, this sign once advertised a chair factory in Morrisville, Vermont. After 1957, when Mrs. Webb bought the chair for the museum, she made it the focus of attention in an exhibition along with carved eagles and hooked rugs hanging from the walls. She was keenly interested in the way her collection was displayed and put much time and energy into finding imaginative solutions.

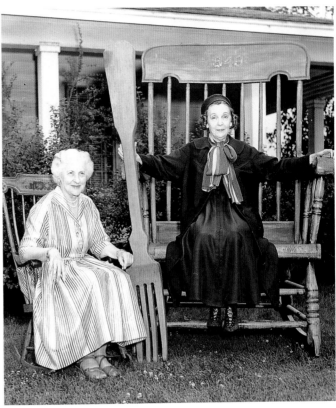

Electra Havemeyer Webb used the big chair as a favorite prop in photographs of friends and family. Here actress Zazu Pitts poses in the chair with Electra on left, July 1958. Shelburne Museum Archives. (PS 1/10 Pitts#1).

The Rug Room, Hat and Fragrance Unit, Shelburne Museum, about 1960 (Dismantled).

The Invention of Folk Art

Most American folk sculpture was first considered art about a hundred years ago. Among the earliest collectors, before World War I, were avant-garde artists, including American sculptors Elie Nadelman and William Zorach, whose work often took its inspiration from folk art. Electra Webb, who began collecting at about the same time, bought and was given folk sculpture from Zorach and Nadelman.

These two artists and fellow members of an artists colony in Ogunquit, Maine, introduced the young Edith Halpert to folk painting and sculpture. In 1929, Mrs. Halpert began selling folk art at her Downtown Gallery in New York City, and she went on to become one of the first and most important folk art dealers in the U.S., providing work to museums all across the country. Mrs. Halpert regarded folk art as the ancestor of modern art, sometimes seeing in it modernist qualities. In 1952 she wrote to Mrs. Webb, "To me, the link between folk art and Modern Art is very strong, and I am convinced that the Shelburne Museum as a whole will not only serve as a living document of past achievement but will also inspire contemporary artists and craftsmen toward higher goals."

Black and White Dog
Maker unknown
19th century
Carved and painted wood
H. 6"; W. 9"; D. 3"
Gift of Mrs. Elie Nadelman,
about 1951
FM-31

Black and White Dog once belonged to sculptor Elie Nadelman (1882-1946), who probably admired it for what he might have described as its purity of artistic impulse — that is, its freedom from academic pretensions. This perspective is shared by many collectors of folk art.

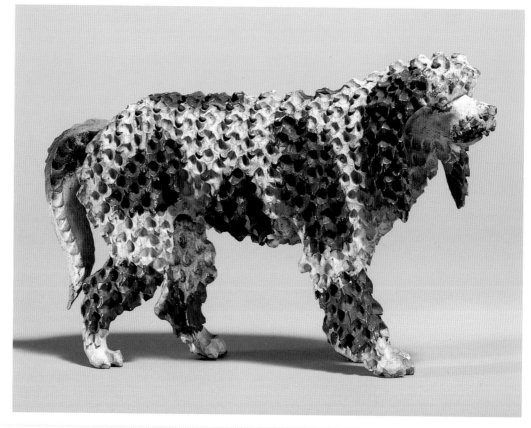

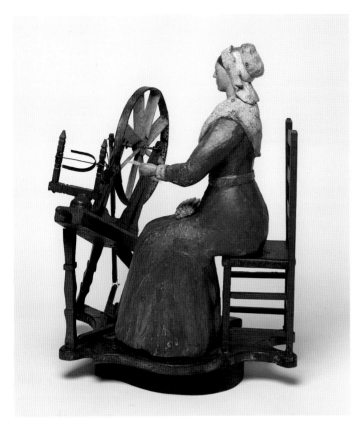

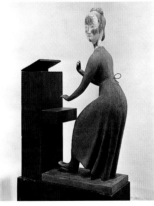

Woman at the Piano, *Elie Nadelman, about 1916. Courtesy of the Museum of Modern Art, New York.*

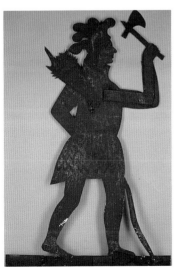

Indian with Tomahawk
Weather vane
Maker unknown
19th century
Sheet metal
H. 41"; W. 28"; D. 1 1/2"
Purchased from John Kenneth Byard, about 1948
FW-6

Spinning Woman
Whirligig
Maker unknown
Late 19th century
Carved and painted wood
H. 28"; W. 23 1/2"; D. 22 1/2"
Purchased from Edith Halpert,
Downtown Gallery, 1953
FT-71

Spinning Woman is one of the finest 19th century whirligigs to have survived. No record of its origins exists, but it was probably made as a trade sign for a New England yarn store. Outside the store, the wind would have turned both the large and small wheels, thus animating the sculpture.

Most whirligigs are relatively simple devices; often they are standing figures with whirling arms or swords shaped like propellers. Although the fundamental concept of wind power is the same, *Spinning Woman* is more mechanically ambitious than most.

It was the simplicity of form, the artistic economy, in pieces like this that made folk art particularly attractive to early 20th century avant-garde artists such as the American sculptor Elie Nadelman. Nadelman's *Woman at Piano* about 1916 (see photo) demonstrates the artist's interest in folk art.

Indian with Tomahawk weather vane once belonged to sculptor Elie Nadelman (1882-1946), one of the earliest collectors of folk art. Nadelman probably considered *Indian with Tomahawk* free from stale artistic conventions and thus closer than academic art to fundamental aspects of human experience.

Born in Poland, Nadelman studied in Paris, where before World War I he was one of a group of avant-garde artists whose work was influenced by their observations of folk and ethnographic art. In 1914 Nadelman emigrated to the U.S. In 1924 he and his wife, Viola Nadelman, founded the first folk art museum in America, the Museum of Folk Arts in New York City. There they exhibited a vast collection of both American and European objects. After the 1929 stock market crash, they began to sell works of art, and eventually their museum closed.

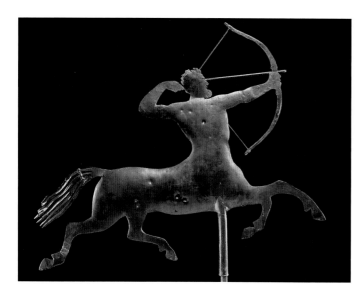

Centaur

Weather vane

Attributed to A. L. Jewell & Co.

Waltham, Massachusetts

Found near New Haven,

Connecticut, late 1940s

Late 19th century

Copper

H. 32"; W. 38"; D. 3"

Purchased from Edith Halpert,

Downtown Gallery, 1950

FW-3

Fifty years ago, Edith Halpert described this vane's balance of design and movement as "remarkable" and its spatial relationships as "extraordinary, comparable to the best in modern art." The sculpture's dramatic silhouette portrays a centaur, one of the race of mythological beasts, followers of Dionysus, who were half man, half horse. Though known generally for their great strength and even savagery, some, such as the centaur Chiron, became the friends and teachers of men.

TOTE

Weather vane

Maker unknown

19th century

Painted sheet iron

H. 51"; W. 32"; D. 1 3/4"

Purchased by Electra Havemeyer

Webb from Edith Halpert,

Downtown Gallery, 1941

FW-4

"TOTE" (pronounced "toh-tay") stands for "Totem of the Eagle," the symbol of a secret fraternal organization, The Improved Order of the Redman, which used American Indian names and expressions.

Electra Webb bought *TOTE* from the Downtown Gallery in New York City in 1941. Edith Halpert, often saw modernist qualities in folk art. For example, *TOTE's* face is in silhouette, but the eye is seen frontally. In the early 20th century, this kind of juxtaposition became typical of the post-Cubist or semi-abstract art which Mrs. Halpert bought and sold.

The "WEBB" weather vane, a copy of Tote, atop the Horseshoe Barn at the Shelburne Museum.

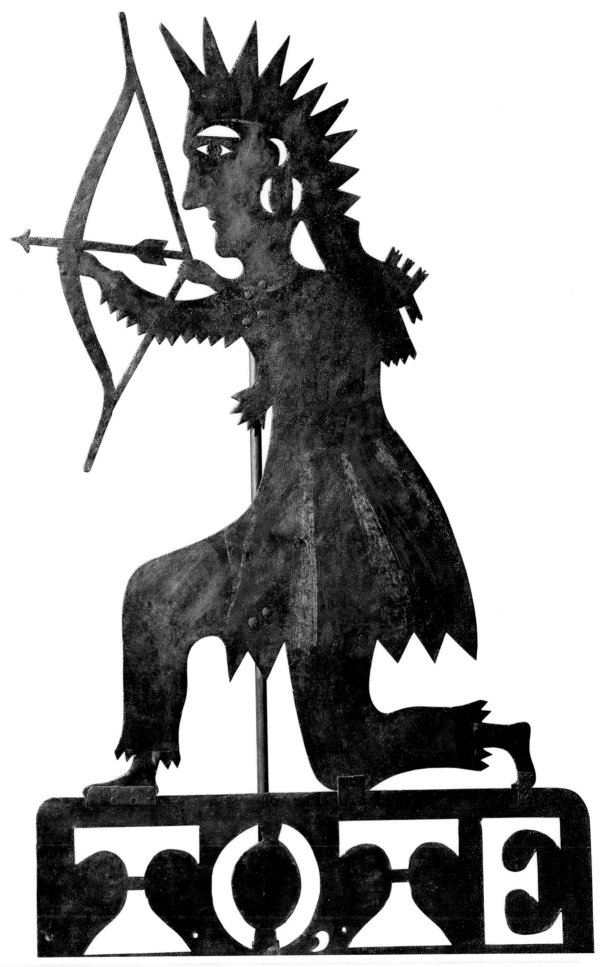

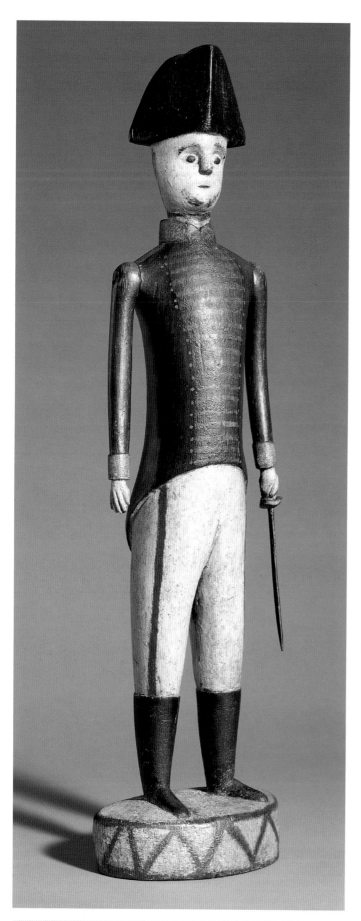

Revolutionary
Soldier
Maker unknown
Early 19th century
Carved and painted wood
H. 26"; W. 6 3/4 "; D. 4 1/4 "
Purchased by Electra Havemeyer
Webb from Edith Halpert,
Downtown Gallery, 1941
FM-5

Revolutionary Soldier was recorded in a 1937 watercolor
for the Index of American Design. Edith Halpert had origi-
nally purchased the carving in 1931 and included it in
several museum exhibitions she organized to promote folk
art as an important art form. Revolutionary Soldier was prob-
ably a child's toy, and may have been part of a set.

Officer of the
American Revolution
Maker unknown
1775-1780
Watercolor on paper
H. 8 1/16"; W. 3 1/4"
Purchased from The Old Print Shop,
New York City
27.2.1-4

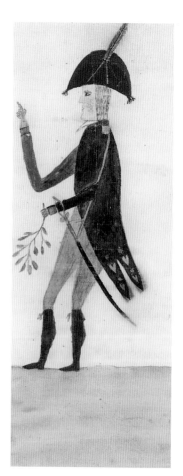

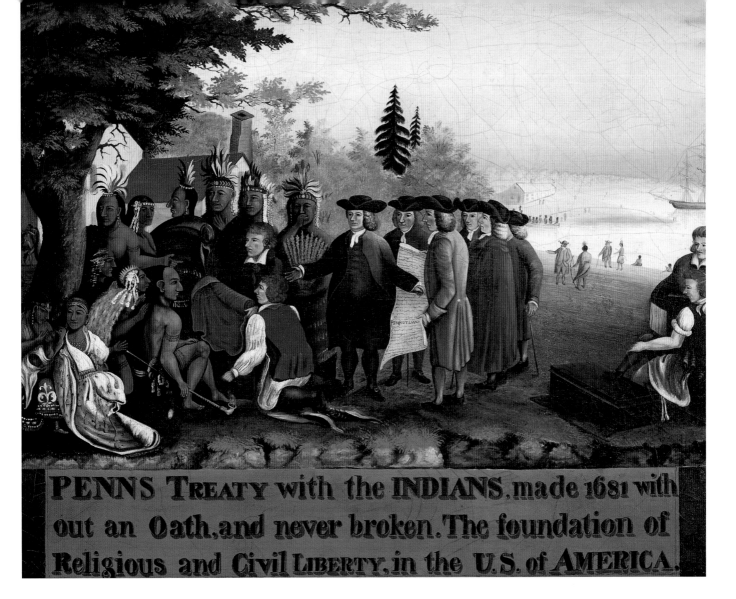

PENNS TREATY with the INDIANS, made 1681 with
out an Oath, and never broken. The foundation of
Religious and Civil LIBERTY, in the U.S. of AMERICA.

**Penn's Treaty with
the Indians**

Edward Hicks (1780-1849)

About 1840

Oil on canvas

H. 36 1/4"; W. 31"

Purchased from Edith Halpert,

Downtown Gallery, 1953

27.1.6-1

To Edward Hicks, as a devout Quaker, the act of peaceful and fair compromise, as exemplified in this subject, embodied fundamental values. Hicks trained as a sign painter, and the bold outlines, bright colors and decorative lettering are typical of trade signs. As an itinerant painter, Hicks most likely saw prints and engravings of Benjamin West's *Penn's Treaty with the Indians* from which he borrowed this composition (see illustration). Nine versions of this

painting by Edward Hicks exist today.

Electra Webb's first passion as a collector was for folk art sculpture, but under the influence of Mrs. Halpert (from whom she bought this canvas) Mrs. Webb went on to purchase for the museum a large group of folk paintings.

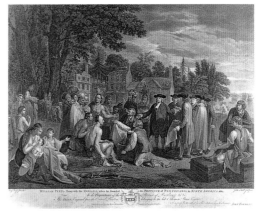

William Penn's Treaty with the Indians when he founded the province of Pennsylvania in North America *(1681). John Boydell, Publisher; John Hall, Engraver after Benjamin West, 1775. The Historical Society of Pennsylvania (HSP), [Accession Bc18 W517].*

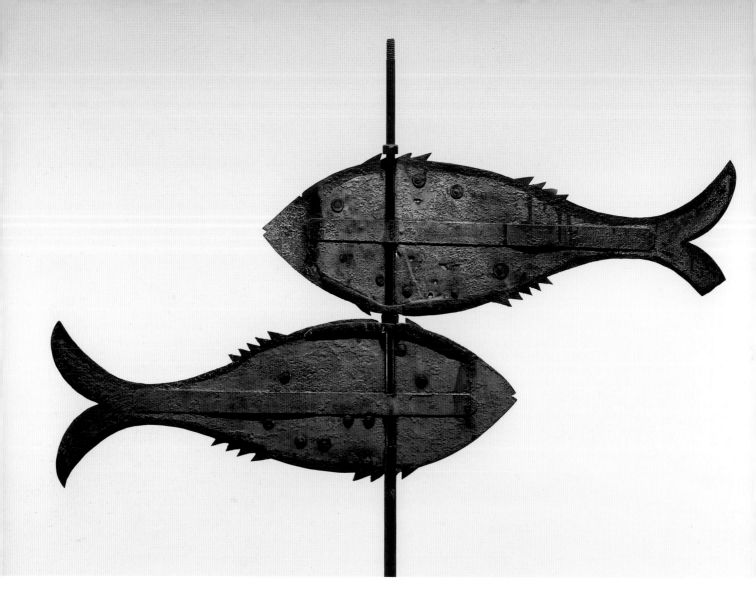

Pisces

Weather vane

Maker unknown

Late 19th century

Painted metal

H. 65 3/4"; W. 42 1/2"; D. 13 1/2"

Purchased from Edith Halpert,

Downtown Gallery, 1951

FW-33

The vane is thought to be a representation of Pisces from the sign of the Zodiac, which is symbolized here by two fish swimming in opposite directions. The simplicity of the forms and the piece's worn painted surface are the striking visual qualities that probably led Electra Webb to buy it.

By the time that Edith Halpert sold this vane to Mrs. Webb in 1951, she had been dealing in folk art for over twenty years. Edith Halpert died in 1970, but her business records survive at the Archives of American Art in Washington, D.C., and provide researchers with insight into her role as a dealer and connoisseur. Among her papers are catalog pages that include historical information about objects as well as where they came from and the amount she paid for them. According to the records, Halpert purchased this vane in March 1951 and sold it to Electra Webb for the Shelburne Museum in May the same year.

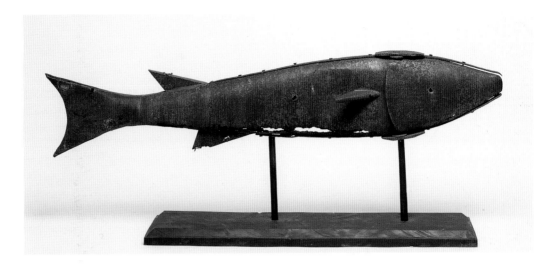

F i s h
Weather vane
Made by Nathaniel Knight
South Walden, Vermont
About 1860
Sheet iron over wood with iron
strappings
H. 10 1/2"; W. 58"; D. 2"
Anonymous gift in memory of
Phyllis K. Orner, 1989
1989-29; FW-128

Nathaniel Knight was a cooper in South Walden, Vermont. The iron straps outlining the fish's body are similar to those traditionally used on wooden barrels. The vane was commissioned about 1860 by the Rev. P. N. Grander for the roof of South Walden's United Methodist Church. It remained there until it was given to the museum in 1989.

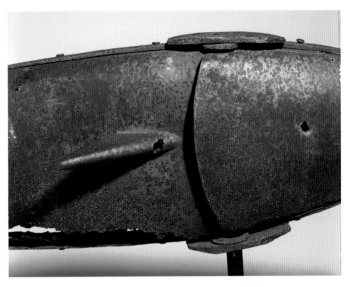

Detail of Fish *showing its rusted surface and edges, which are an integral part of its aesthetic appeal.*

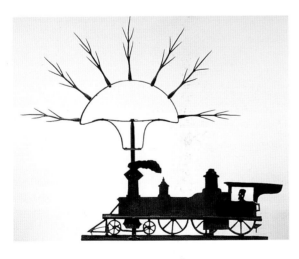

L o c o m o t i v e
Weather vane
Maker unknown
Mid-19th century
Sheet zinc, brass, and iron
H. 22"; W. 44"; D. 3"
Purchased from Edith Halpert,
Downtown Gallery, 1950
FW-34

Mrs. Halpert reported that this vane came from a railroad station in Providence, Rhode Island. It is one-of-a-kind, not factory made. The iron sunburst, which probably was added later to serve as a lightning rod, gives the vane much of its distinctive character. The rods are in sharp contrast to the flatness of the sheet metal locomotive.

Joel Barber, an architect in New York City, was also a highly respected decoy collector and promoter, and a watercolorist and writer. He painted this image for the frontispiece of his influential 1934 book, *Wild Fowl Decoys*, which features his collection. The modernist style of Barber's watercolor demonstrates the link that can often be traced between the early collectors of folk art and their interest in modern art. The caption reads, "Chesapeake Bay Canvas-back Susquehanna Flats about 1880." When putting together *Wild Fowl Decoys*, Barber wrote, "No one has ever bothered about them as I have, perhaps no one ever thought about it. But it is my wish that the decoy ducks of American duck shooting have a pedigree of their own. For this reason I became collector and historian."

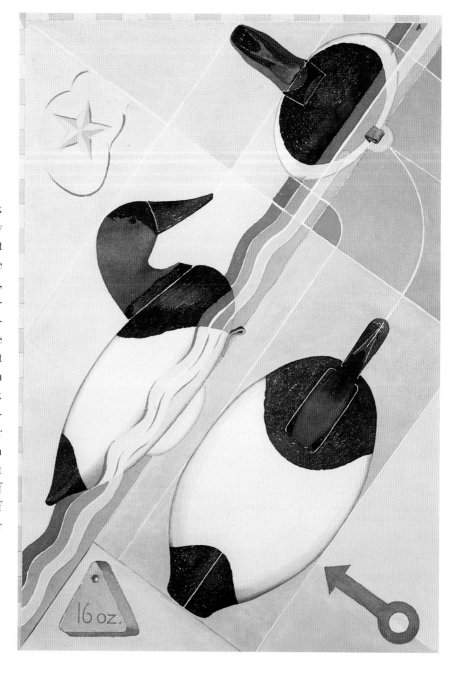

The decoy was made by Robert McGaw, whose work, which dates mostly from after 1910, was praised by Joel Barber, one of the earliest connoisseurs and collectors of decoys. McGaw hunted in the Chesapeake Bay where he and Barber became friends.

Barber, who once owned this canvasback decoy, was one of the first to appreciate decoys for their artistic quality, beginning about 1918. He sometimes referred to them as "floating sculpture." When Barber's collection was exhibited in 1923, it was the first time that decoys were described and viewed as works of art.

Mrs. Webb was a keen sportswoman; she had her own decoys for hunting, which are now part of the museum collection, and in 1952 she purchased Joel Barber's entire collection — more than four hundred decoys (including this one).

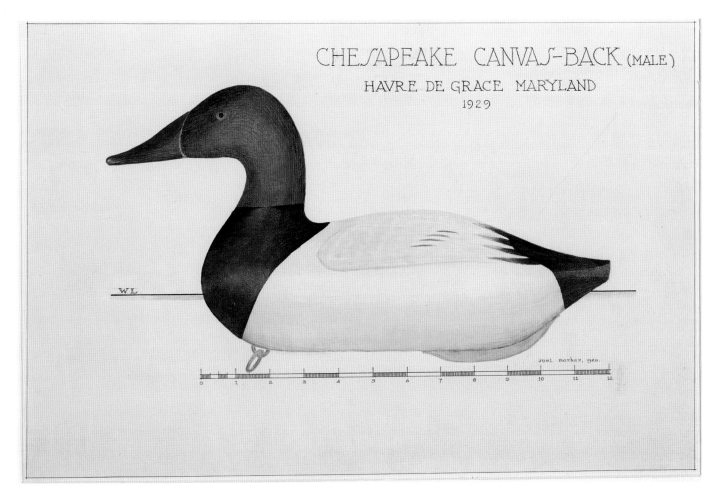

CHE/APEAKE CANVA/-BACK (MALE)
HAVRE DE GRACE MARYLAND
1929

WL

joel barber, 1929.

Canvasback Decoy
Joel Barber (1877-1952)
1929
Watercolor, ink and graphite on paper
H. 15"; W. 21 1/2"
Purchased from the estate of Joel Barber, 1952
27.2.5.1-258

Joel Barber painted this image of the McGaw canvasback decoy for his 1934 book, *Wild Fowl Decoys.*

Barber was an ardent sportsman and promoter of decoys. When putting together *Wild Fowl Decoys*, which features his collection, he wrote, "My book is like an island, a single gesture in the midst of unrelated activities. No one has ever bothered about them as I have, perhaps no one ever thought about it."

In 1952 the Shelburne Museum purchased Barber's entire collection — more than 400 decoys by some of the best makers including Charles E. "Shang" Wheeler, A. Elmer Crowell and Lee Dudley. Today this collection remains the centerpiece of the museum's decoys, which now number over one thousand.

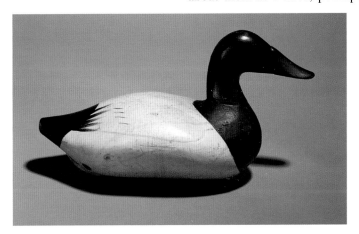

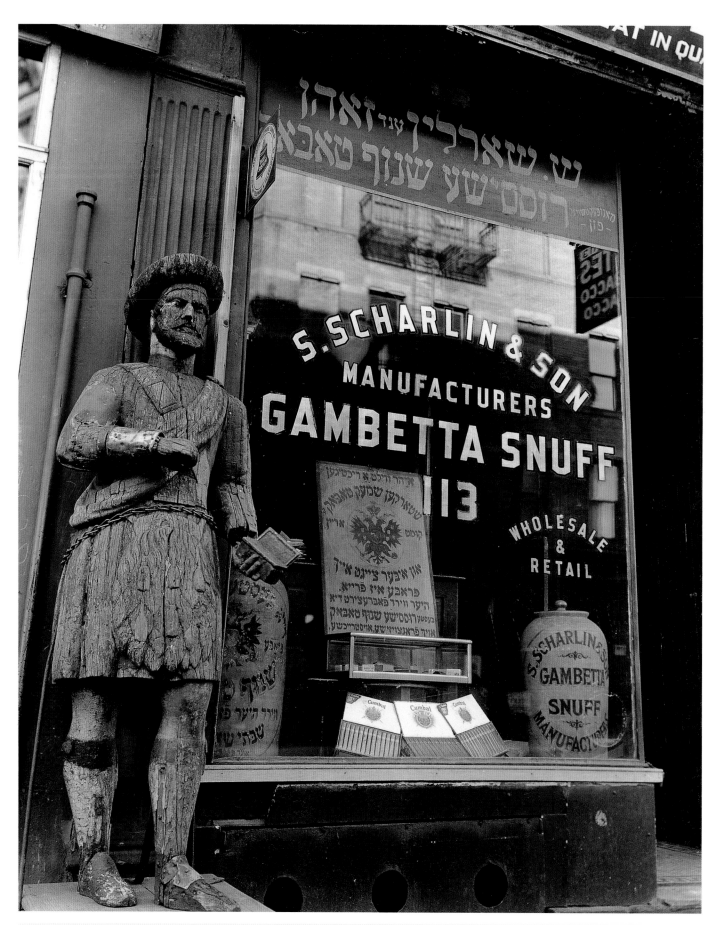

Folk Art at Work

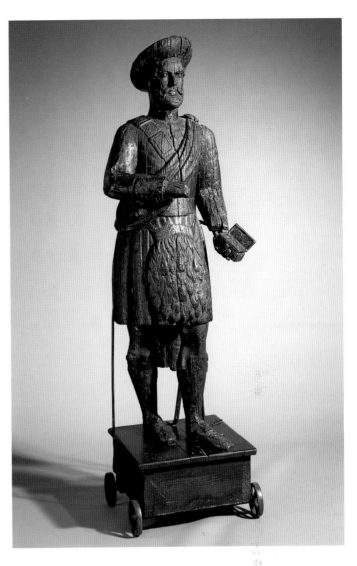

Much of what we call folk art was originally made for a specific purpose, but today the pieces are often separated from their original contexts, on display in public or private collections. Nonetheless, the original functions of folk art objects, often forgotten, are an integral part of these objects' histories. Here are some examples with photographs showing the pieces in American streetscapes that were commonplace less than a hundred years ago.

Sandy the Scotsman
Cigar store figure
Maker unknown
About 1870
Carved and painted wood
H. 85"; W. 28"; D. 26"
Purchased by Electra Havemeyer Webb in 1939,
probably from Sidney Scharlin
FT-20

From 1873 through the 1930s this figure stood outside Sidney Scharlin's snuff factory at 113 Division Street in New York City. In 1938, photographer Berenice Abbott documented *Sandy* on Division Street as part of her series, "Changing New York," sponsored by the federal government's Works Progress Administration.

When new city regulations required clearing sidewalks of obstructions, including cigar store figures, the factory fought to keep *Sandy the Scotsman* on the sidewalk. In 1938, however, city authorities removed the figure to a garbage dump, from which Mr. Scharlin rescued it. In 1939 Electra Webb purchased it for her collection.

The taking of snuff (powdered tobacco sniffed through the nose) was once widely popular in Scotland, hence Scotsmen became the subjects of cigar store figures.

Electra Webb relished the visual effects of weathered and worn folk art sculpture.

Snuff Shop, 113 Division Street, *Berenice Abbott, January 26, 1938.*
Courtesy of the Museum of the City of New York.

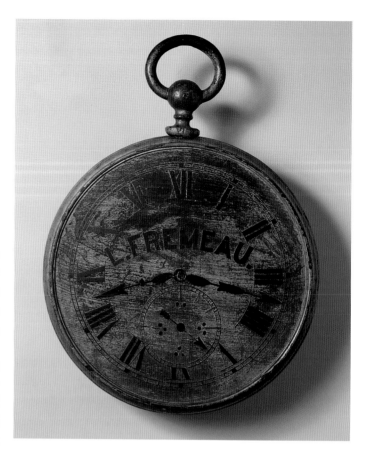

Louis Fremeau Jewelers

Trade sign

Maker unknown

Burlington, Vermont

19th century

Carved, painted wood

H. 22"; W. 16"; D. 3"

Gift of Mrs. Louis Fremeau, 1958

1958-5b; FT-83

This oversized image of a pocket watch advertised the shop of Louis Fremeau, one of many jewelers in 19th century Burlington, Vermont, seven miles from the Shelburne Museum. The photograph below shows Church Street where the sign hung, along with a number of other jewelers' signs, all competing for attention.

Originally from Canada, Louis Fremeau opened a shop at 14A-16 Church Street in the early 1840s after an apprenticeship in New York City. Later, his sons ran the shop, until the 1920s when it was bought and moved. It re-opened under the same name at its present location at 78 Church Street.

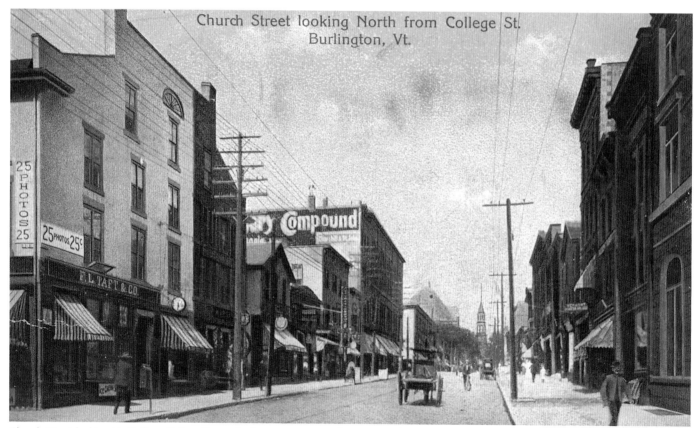

Church Street looking North from College Street, Burlington, Vermont, about 1900. Shelburne Museum Archives.

Mortar and Pestle

Trade sign

Maker unknown

Mid-19th century

Polychromed zinc and copper

H. 35"; W. 17 3/4"; D. 20"

Purchased from Henry Coger, 1962

1962-70; FT-108

An apothecary or pharmacist ground and mixed ingredients in a "mortar" (bowl) with a "pestle" (a club-shaped grinding tool). Apothecaries could be immediately recognized on a city street by the large mortar and pestle signs. This one is more elaborate than most with the eagle perched on the mortar, holding a miniature mortar and pestle in his beak. The mortar and pestle have been associated with medicine since at least 1550 B.C. in Persia and Egypt. American apothecaries mixed their own medicines until pre-bottled patent medicines became more readily available after the Civil War.

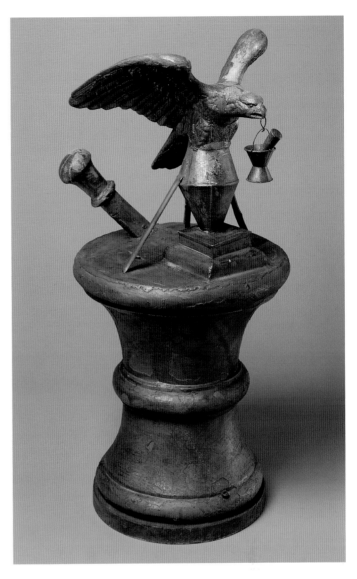

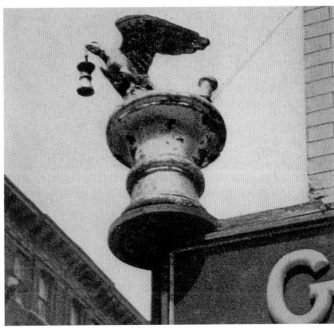

Mortar and pestle, First Avenue, New York City. Courtesy of The Magazine ANTIQUES.

Roby Barn, about 1900, with Mermaid *weather vane. Courtesy of the Wayland Historical Society, Wayland, Massachusetts.*

Mermaid
Weather vane
Warren Gould Roby
(1834-1897)
Wayland, Massachusetts
About 1850
Carved wood and metal
H. 22 1/2"; W. 52 1/2"; D. 4 1/2"
FW-47

Warren Roby, who once trained as a coppersmith, became a successful businessman buying and selling copper and other metals. He carved this one-of-a-kind weather vane for his summer house in Wayland, Massachusetts. Perhaps he was inspired by the English ballad "The Mermaid," which was popular in New England in the mid-19th century. Wooden patterns often were used as prototypes for copper vanes, but there is no evidence that this vane was ever produced in metal.

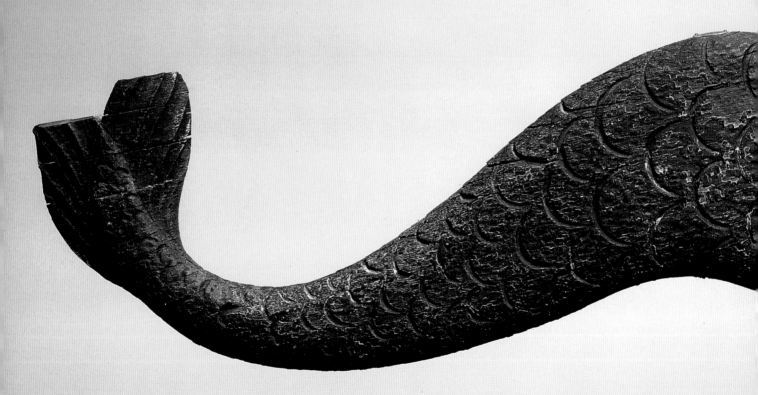

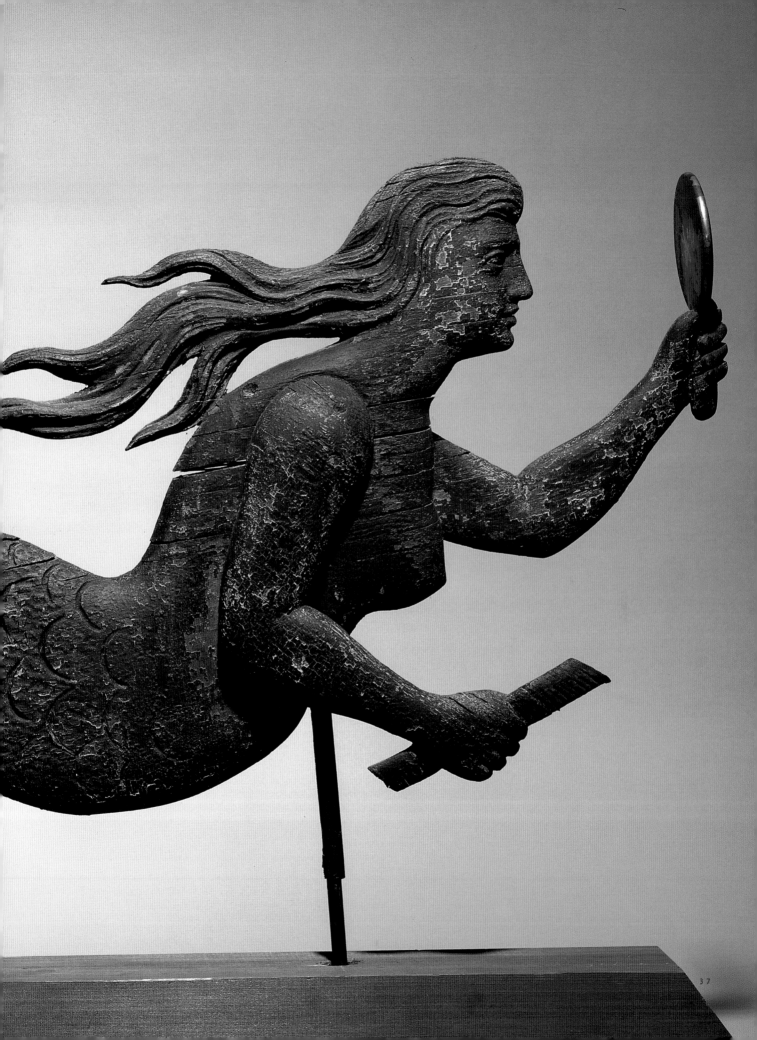

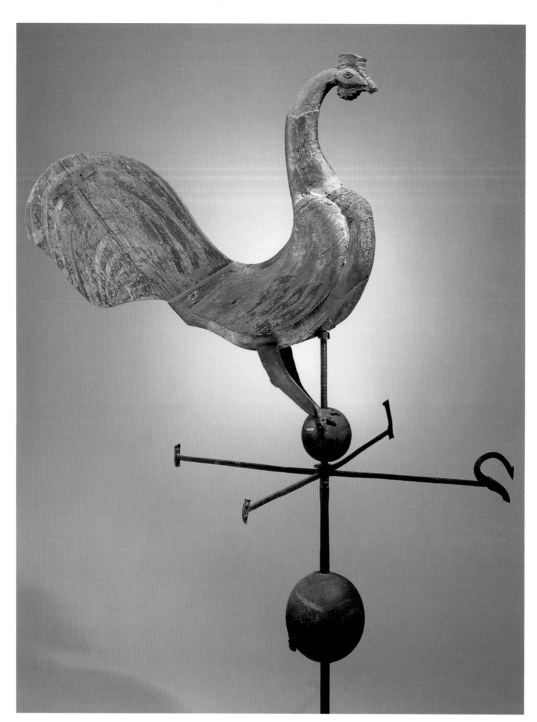

Rooster

Weather vane

Maker unknown

Late 18th century

Carved and painted wood, iron

H. 34"; W. 45"

Purchased from John Kenneth

Byard, 1930s

FW-50

Fitch Tavern, Bedford, Massachusetts. Courtesy of the Bedford Historical Society

This impressive rooster once stood atop the barn of the old Fitch Tavern in Bedford, Massachusetts. Here, the American militiamen known as Minute Men rallied on April 19, 1775, before the Battle of Concord, the first battle of the Revolutionary War. The vane is an extremely rare surviving example of 18th century folk art. The majority of American folk art dates from after 1800.

The Eye of the Maker

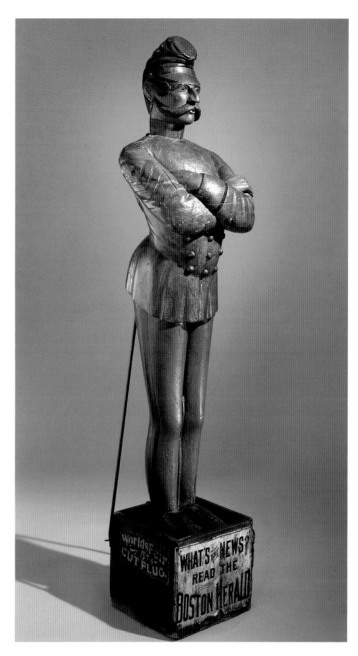

The names and histories of most folk art makers are lost. But on the next few pages are several objects for which the makers have been identified. These include a splendid figure of Samuel Robb, the cigar store figure carver, by Thomas White; the well-known painting, *The Garden of Eden,* by the itinerant artist Erastus Salisbury Field, and a decoy by A. Elmer Crowell, probably the most highly regarded carver of decoys.

Through our knowledge of these pieces we gain insight into the world of the makers. Some worked alone, others with assistants, and some in factory settings, but their individual talents lifted their work from the realm of the purely functional to the realm of art.

Samuel Robb as Captain Jinks

Cigar store figure

Thomas J. White (1825-1902) in the New York City workshop of Samuel Robb

About 1879

Carved and painted wood

H. 75"; W. 18"; D. 17"

Gift of Mr. and Mrs. Robert Choate, 1959

FT-35

The face of this figure is a portrait of the wood carver Samuel Robb (1851-1928) whose New York City workshop (see photo) was one of the most prolific producers of cigar store figures. Robb's manufactory flourished between about 1875 and 1910, making what were then called "show figures" to stand outside storefronts advertising tobacco products.

In the late 1870s when this figure was made, Captain Jinks was a character from a popular Civil War song, "Captain Jinks of the Horse Marines," which mocked the captain's laziness in the army. The figure was carved by craftsman Thomas White, who created a portrait of his boss, Samuel Robb. He wears the uniform of the National Guard, which Robb had joined in 1879. White worked in the Robb shop off and on for more than twenty years, beginning in 1876.

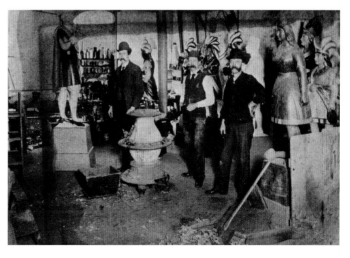

The carving shop of Samuel A. Robb at 195 Canal Street, Manhattan, about 1879. Robb stands on the far right, Thomas White in the center. Fred Fried papers, Archives Center, National Museum of American History, Smithsonian Institution.

Man with a Pipe
Cigar store figure
Louis Jobin (1845-1928)
Quebec, Canada
Late 19th or early 20th century
Carved and painted wood
H. 79"; W. 21"; D. 22"
Purchased from Paul Carluccio, 1985
1985-35, FT-174

French-Canadian Louis Jobin completed his three-year Quebec City apprenticeship in sculpture in 1868. For the next two years, he lived in New York City carving cigar store figures in lower Manhattan. After he returned to Canada in 1870, he spent most of his working life in and around Quebec. Jobin is best remembered for his large-scale memorial and religious sculptures.

This figure once stood outside a general store in Greenville, Maine. Figures from Jobin's workshop generally assume this pose and include the tall headdress profile seen here.

Studio and home of Louis Jobin, Quebec. Fred Fried papers, Archives Center, National Museum of American History, Smithsonian Institution.

Man with a Tomahawk

Cigar store figure

John Cromwell (1805-1873)

New York City

About 1850-60

Carved and painted wood

H. 70 1/2"; W. 16 1/4"; D. 21"

FT-2

Early in his career John Cromwell was a ships' carver but, with the end of the sailing ship era, ships' carvers often turned to other forms of production, including cigar store figures. Because *Man with a Tomahawk* seems to push slightly forward like a ship's figurehead, it is thought that this is one of Cromwell's earliest cigar store figures. Note the finely modeled face and carefully drawn expression. On its back is a hook once used to secure it to a storefront.

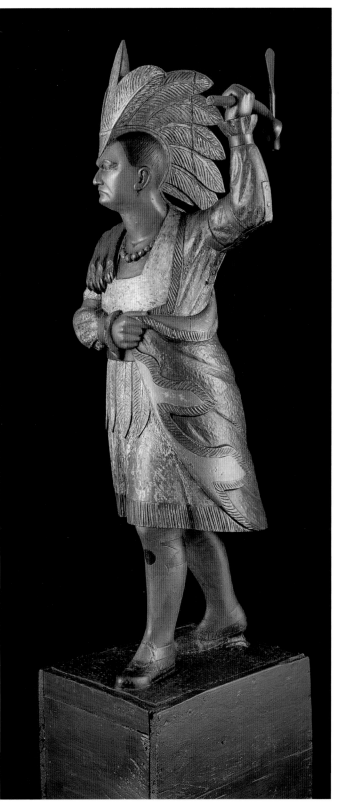

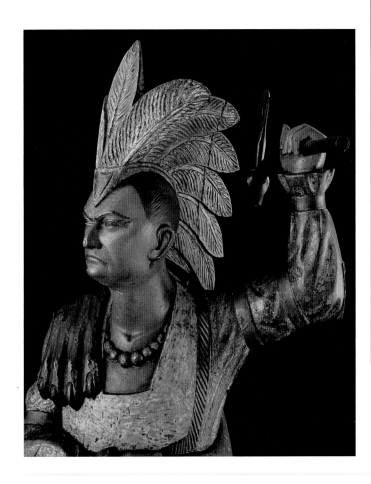

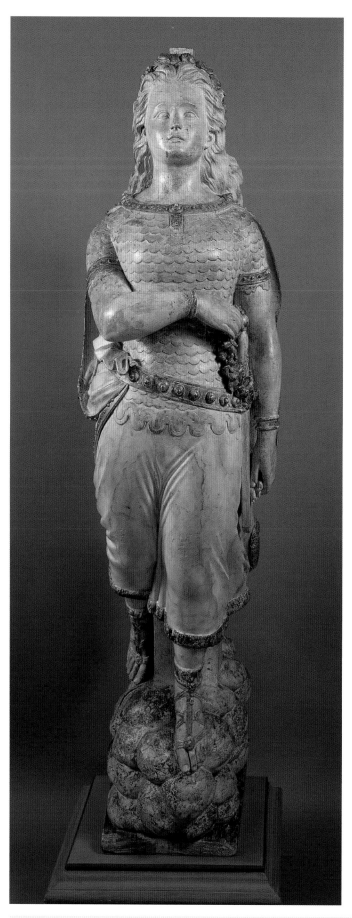

Brunhild

Ship's figurehead

Attributed to Charles A. L. Sampson, active about 1850-1880 Bath, Maine

Found on Nantucket Island, Massachusetts

Carved and painted wood

H. 82"; W. 22"; D. 30"

Purchased from The Old Print Shop, New York City, early 1950s

FS-16

This boldly carved figure from the bow of a late 19th century American ship is a rare example from the workshop of Charles Sampson, a professional carver in the ship-building city of Bath, Maine. Only a small number of carvings associated with Sampson survive. In the 1870s his shop is known to have made decorative carvings for the ships *Northern Empire* and the *Viking*. Although no evidence directly links this figure to either of these ships, it might have come from one of them.

According to Germanic mythology, Brunhild was a fierce warrior queen, or, in the Icelandic version, the equally fierce chief of the Valkyries, who brought about the death of her beloved, Sigfried (or Sigurd) as a result of his betrayal. Since antiquity, figureheads have been thought to give protection to ships and their crews. Brunhild's image may have served as a figurehead simply because of her reputation for power and strength.

View of South Street, New York, 1876, showing a figurehead clearly visible on the right. Fred Fried papers, Archives Center, National Museum of American History, Smithsonian Institution.

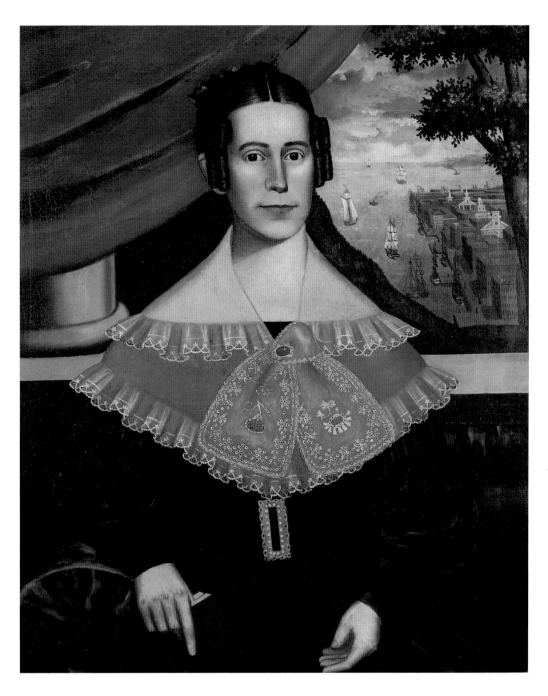

Louisa Gallond

Erastus Salisbury Field (1805-1900)

About 1835

Oil on canvas

H. 39 1/2"; W. 34 1/2"

Purchased from Maxim Karolik, 1959

27.1.1-127

This is probably Erastus Salisbury Field's finest surviving female portrait. Its composition, with a red curtain drawn back to reveal an unidentified seaport, suggests Renaissance-based portraiture traditions. The figure is flat, like those in 16th century English portraits. Field appears to have known little of 17th and 18th century innovations in portraiture, which partly accounts for his being considered a folk artist.

The identity of the subject remains uncertain: she is one of two Gallond sisters, Louisa or Almira, from Petersfield, Massachusetts. They were close in age, looked very much alike, and married two brothers, becoming Louisa and Almira Cook. The portrait itself includes no identification.

Maxim Karolik was a well-known collector in Boston from whom Mrs. Webb bought many paintings.

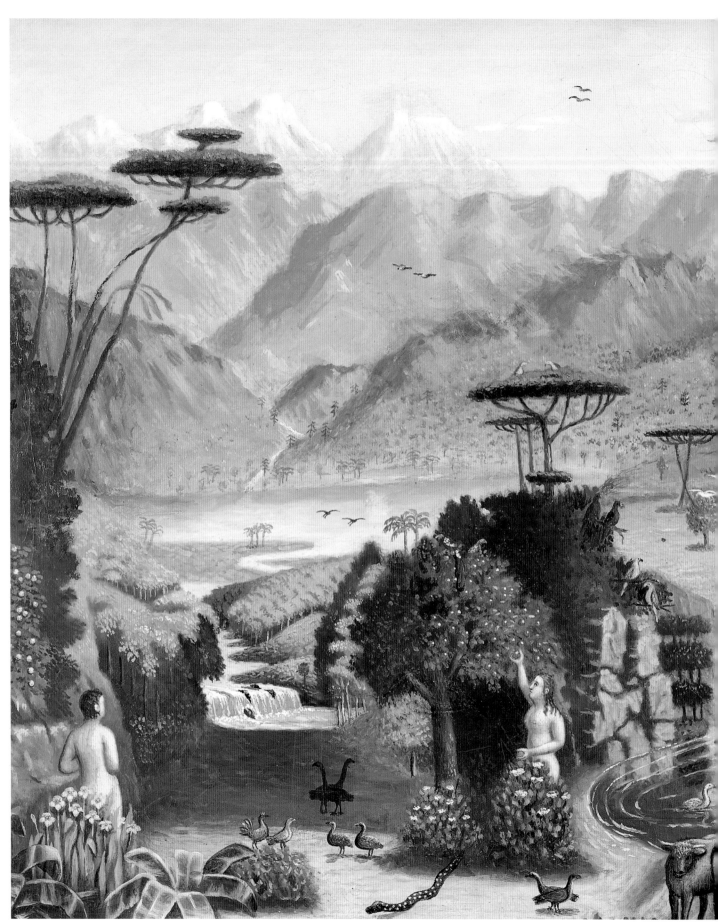

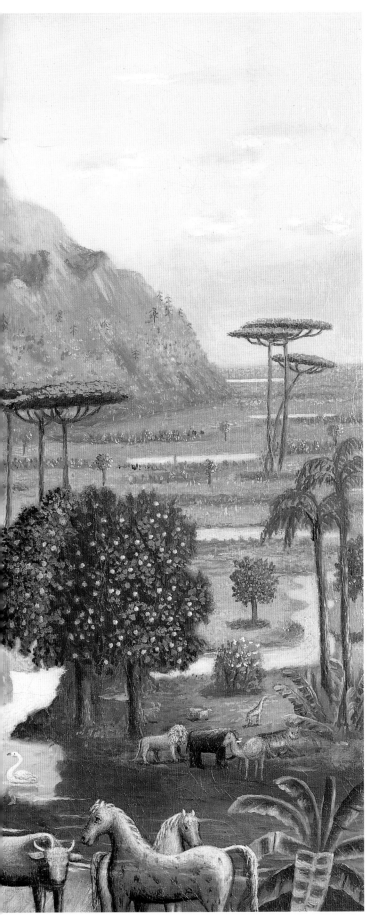

The Garden of Eden

Erastus Salisbury Field (1805-1900)

Sutherland, Massachusetts

About 1865

Oil on canvas

H. 37"; W. 44"

Gift of Electra and Dunbar

Bostwick, 1959

27.1.2-86

In the 1820s and 1830s, after briefly studying with the painter Samuel F. B. Morse (1791-1872) in New York City, Erastus Salisbury Field worked as an itinerant portraitist. In the 1840s, he turned to painting religious subjects. The artist's composition in *The Garden of Eden* is based partly on prints by the idiosyncratic Englishman John Martin, well-known in America for his visionary subjects. However, in this picture Erastus Salisbury Field demonstrates that he has his own richly articulated vision of Eden and goes so far as to paint his own illusionistic blue and gold frame.

The Garden of Eden *showing the artist's illusionistic blue and gold frame.*

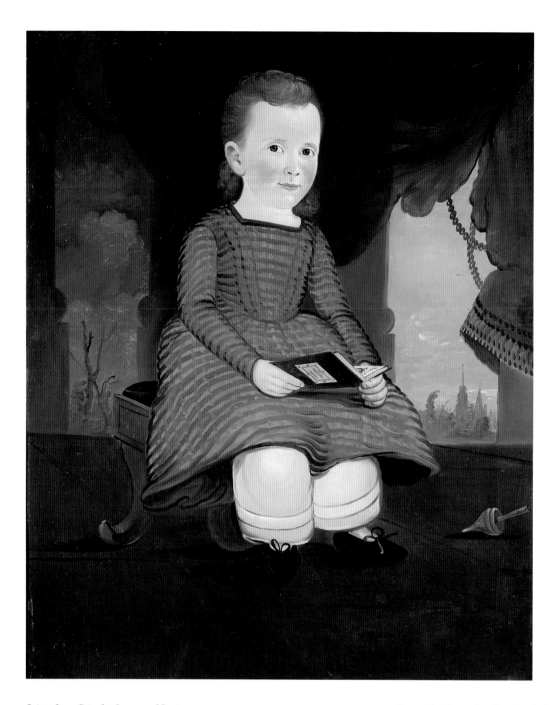

Little Girl from Maine

William Matthew Prior (1806-1873)

Oil on canvas

Inscribed on back: "Wm. M. Prior/East Boston/April 1846/Value $20"

H: 39 3/4"; W. 32 3/4"

Gift of Dr. and Mrs. Fletcher McDowell, 1959

27.1.1-72

Inscribed on the back of the portrait is "Value $20" — significantly more than the $2.92 which the artist advertised for smaller, "flat," less finished paintings. Prior probably charged more because the painting is full length, the face is highly detailed, and a toy, a book, and a landscape background are included.

William Matthew Prior traveled widely in New England painting portraits. In 1839 he moved to Boston. The inscription on the back of this picture, "East Boston," refers to a studio he had there from 1846 to 1873.

Edgar Clark (1854-1906)

William Matthew Prior (1806-1873)

1856

Oil on academy board

H. 15 1/4"; W. 11"

Purchased from Richard Gipson, 1958

27.1.1-91

Of the three portraits painted by Prior illustrated here, this small painting would have cost the least. Its small size, the loose, swirling brush strokes and lack of depth suggest rapid execution, and therefore, a lower price. Edgar Clark was the son of Captain Jeremiah Clark and Diana Pierce Clark of New Bedford, Massachusetts. It appears that Prior painted Edgar's portrait, along with the rest of the Clark family, in 1856.

Child with Rabbit

William Matthew Prior (1806-1873)

About 1845

Oil on canvas

H. 27 3/8"; W. 22 3/8"

Purchased from Maxim Karolik, 1957

27.1.1-136

In the mid-19th century, boys and girls wore the same style of pantaloons and dress until they were about six years old. We no longer know the identity of the children in many portraits, including this painting, but one of the most reliable ways to identify a sitter's gender is by the hair style. Boys usually parted their hair on the side, as in this portrait, while girls' hair was typically parted down the center.

The portraitist William Matthew Prior, who was active in Boston and many parts of New England between 1830 and 1860, is well known for his portraits of children.

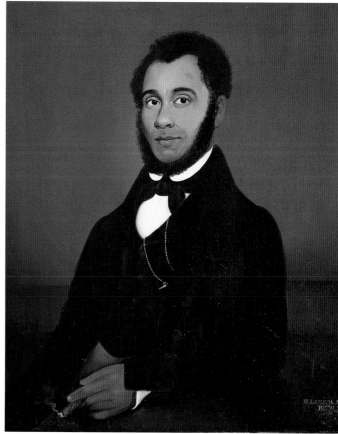

Mrs. Nancy Lawson

William Matthew Prior (1806-1873)

Signed lower right: "Nancy Lawson.

May 11 1843/W. M. Prior"

1843

Oil on canvas

H. 30"; W. 25"

Purchased from

Maxim Karolik, 1958

27.1.1-124

The Reverend W. Lawson

William Matthew Prior (1806-1873)

Signed lower right: "W. Lawson.

May 2nd 1843/ By W. M. Prior"

1843

Oil on canvas

H. 30"; W. 25"

Purchased from

Maxim Karolik, 1958

27.1.1-125

William Matthew Prior traveled throughout New England painting portraits, and finally settled in Boston in 1839. In the mid-19th century, free African Americans made up less than one percent of New England's population, and very few portraits of African Americans survive. The Reverend Lawson was listed as a clothing merchant in Boston's "People of Color" directories of 1841 and 1850. These are two of Prior's very best works from his entire career.

Jane Henrietta Russell

Joseph Whiting Stock (1815-1855)
Signed on back: "J. W. Stock/1844"
Springfield, Massachusetts
Oil on canvas
H. 52 3/4"; W. 40 3/4"; 2 3/4"
Purchased from Maxim Karolik, 1959
27.1.1-129

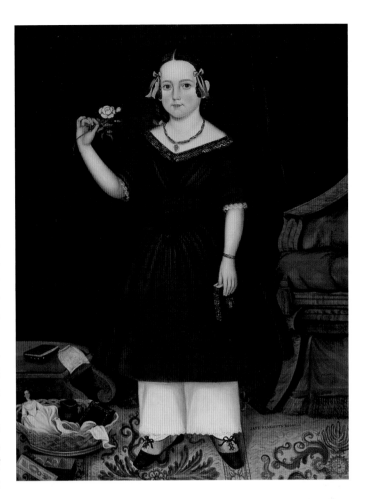

This portrait was painted after its subject had died; the portraitist, Joseph Whiting Stock, recorded in his journal that he was commissioned to paint the portrait of "Henrietta Russell corpse . . ." for $16. This was not an unusual practice in an age when many young children died before reaching maturity. For grieving parents the portrait would be the only visual record of their child.

Like many 19th century artists, Stock traveled from town to town in search of business. Paralyzed from the waist down and confined to a wheelchair, he painted almost a thousand portraits of individuals from all over New England.

By painting the carpeted floor so that it appears more vertical than horizontal, Stock seems to reject the convention of three-dimensional illusionism. However, the rest of this highly detailed picture is painted with a strong interest in depth and perspective.

Child in White Dress

Artist unknown
About 1850
Pastel on paper
H. 16 13/16"; W. 13"
Gift of Mrs. J. C. Rathborne, 1958
27.3.1-23

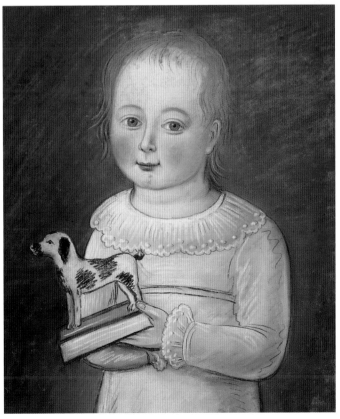

The child in this pastel portrait holds a squeak toy, a plaything popular during the 19th century. Squeak toys are usually single animal figures made of wood, plaster, or composite, mounted onto wooden platforms with bellows attached beneath. By squeezing the bellows, a child would cause the animal to produce a squeak.

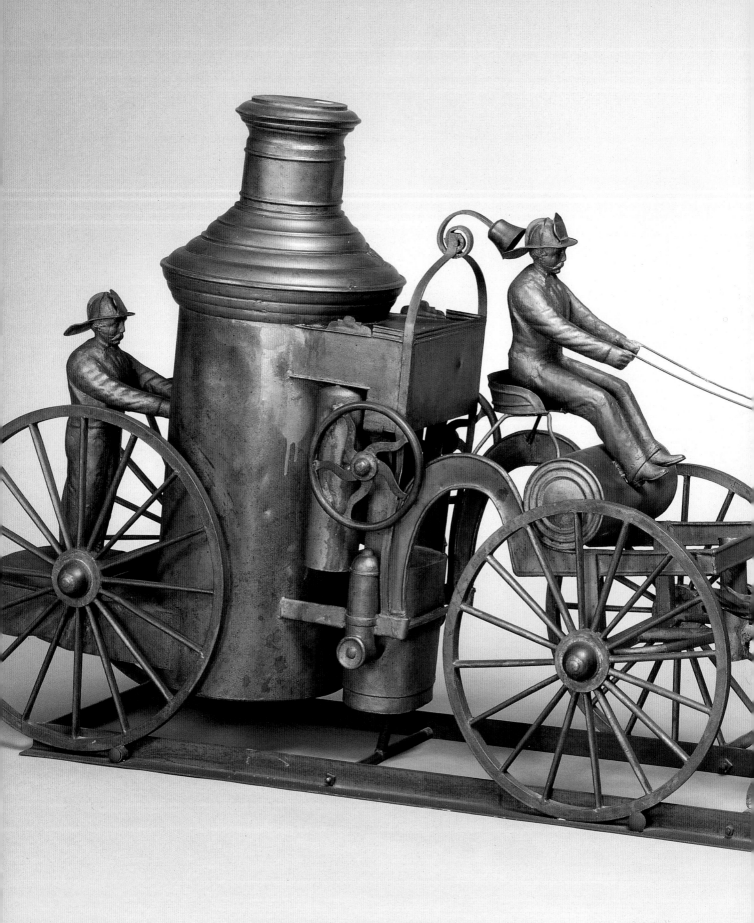

Fire Engine
Weather vane
Attributed to J. W. Fiske Company
New York City
Found in Manchester,
New Hampshire
Late 19th century
Copper and other metals (brass,
zinc, and iron)
H. 37"; W. 88 3/4"; D. 16 1/2"
Purchased from Edith Halpert,
Downtown Gallery, 1952
FW-35

The weather vane was once used on a firehouse in Manchester, New Hampshire. It is the largest and grandest weather vane in the museum's collection and is a reminder of how ambitious designers were in the late 19th century in their quest to make an impressive silhouette on a firehouse roof.

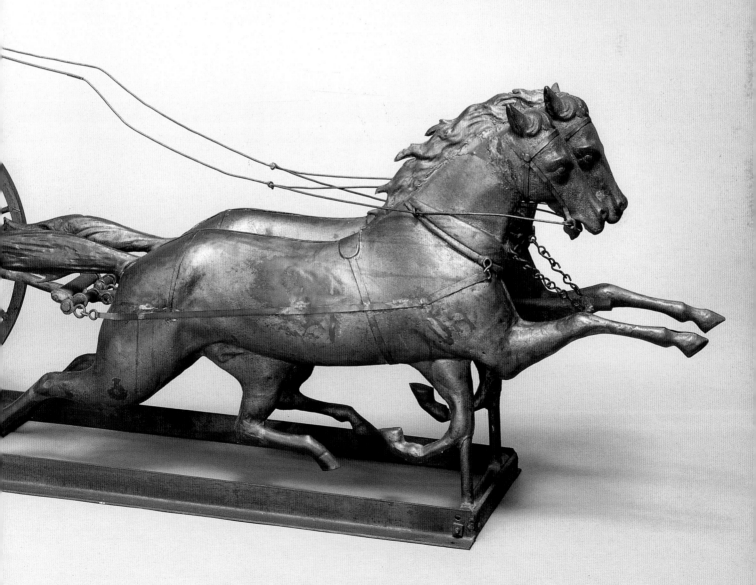

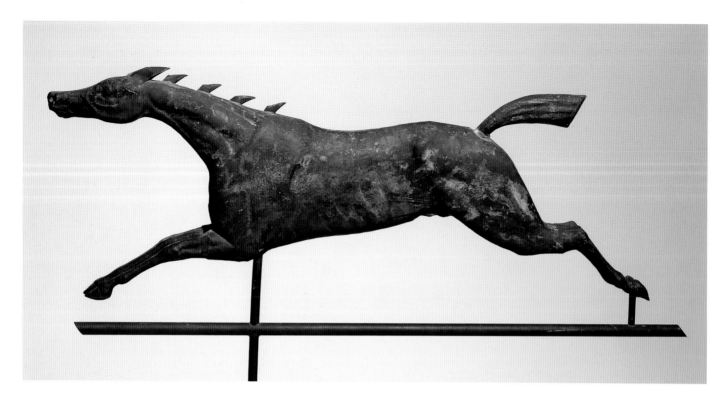

Hindoo

Weather vane pattern, molds and
weather vane
L. W. Cushing & Sons, 1872-1933
Waltham, Massachusetts
Molds and pattern about 1881,
weather vane 1955
Carved wooden patterns, iron
molds, copper weather vane
Pattern: H. 9 1/4"; W. 27"; D. 1 1/4"
Mold: H. 7 1/2"; W. 16 1/2";
D. 5 3/4"
Weather vane: H. 32"; W. 19";
D. 2 1/2"
Gift of Edith Halpert, 1957
1957-54; FW-79

In 1955, Edith Halpert, Downtown Gallery owner, discovered this set of patterns and molds from one the best-known 19th century manufacturers, L. W. Cushing & Sons. She had this weather vane made from the mold in 1955.

Cushing & Sons often chose popular forms like this famous racehorse, Hindoo, whose success in 1881 led the year to be known as "Hindoo's Year" in racing history. The vane was almost certainly inspired by the Currier and Ives print *Hindoo, Winner of the Kentucky Derby, 1881*, but no impressions of the print are known to exist.

In manufacturing weather vanes, firms commissioned a craftsman to carve a wood pattern as illustrated here. From that, an iron mold was made, into which sheets of copper were hammered to create two sides of a vane, which were then soldered together.

Weather vane manufacturers promoted their goods through catalogs and posters like the one pictured here. This poster is for Cushing & White, precursor of L. W. Cushing & Sons.

Cushing & White advertisement for weather vanes, late 19th century.
Shelburne Museum.

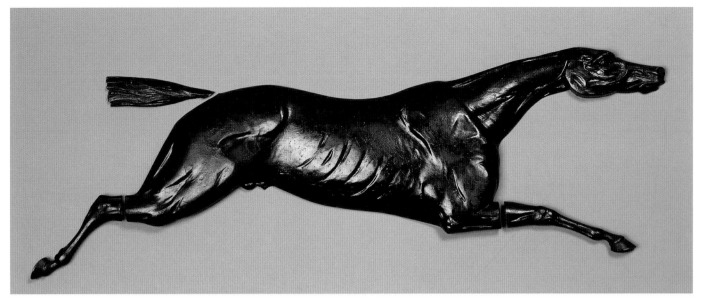

Wood carved pattern for one side of the weather vane and tail.

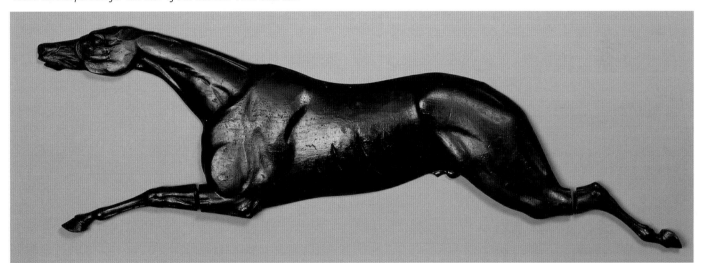

Wood carved pattern for one side of the weather vane.

Iron molds for one side of the front and back legs.

Iron molds for each side of the weathervane formed from the wood patterns, into which sheets of copper were hammered to create two side of a vane, which were then soldered together.

Bed Rug

Mary Bishop Comstock (1744-1826)

Shelburne, Vermont

1810

Wool

L. 84"; W. 76 1/2"

Gift of Mrs. Henry Tracy, 1952

1952-607; 10-86

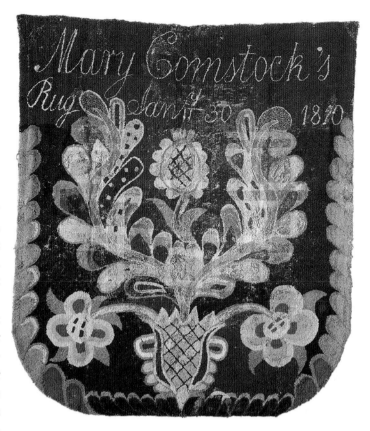

Made in Shelburne, Vermont, the neoclassical flower-and-leaf motif of this 1810 bed rug is typical of the period, but its enormous scale is not. A more conventional design would have included a smaller pattern, repeated several times. It is the unusual design and the huge inscription that make the rug remarkable.

Mary Comstock made this rug when she was sixty-six years old by which time bed rugs, which had been popular in her youth, were considered old fashioned. Using a hand-woven plaid twill rug with a pile surface (which she may or may not have woven herself) she embroidered the design onto the blanket in a looped running stitch with handspun wool yarns. Comstock boldly identified herself, working into the design the words, "Mary Comstock's Rug, Jan y 30 1810."

Sampler

Mary Eaton

1763

Silk embroidered on linen

L. 14 3/4"; W. 12 1/2"

8.2-47

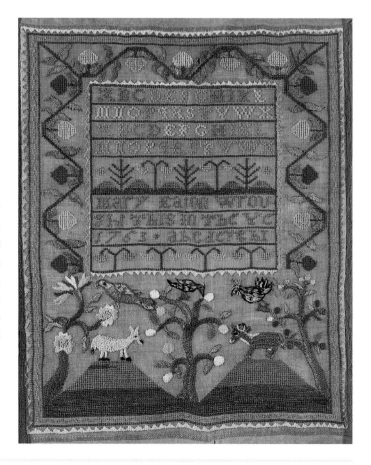

Samplers are so named because they display a sample of the skills the maker has mastered. Here Mary Eaton displays her ability to do cross stitch (in the letters, numbers, vine, strawberries, mounds, border), stern stitch (in the outline of the birds), satin stitch (in the pointed border, leaves, white fruit), long and short stitch (in the trees, leaves, goat, fruit and flowers), and French knots (in the sheep and center of the flowers). In the 18th century these were just some of the skills women needed to make and mend clothes and linens.

Haskins Crazy Quilt

Delphia Ann Noice Haskins (Mrs. Samuel Glover Haskins) (1816-1892)

Rochester, Vermont

1870-1880

Cotton, pieced, appliquéd and embroidered

L. 83"; W. 70 1/4"

Purchased from Mrs. John Fairchild, 1956

1956-648; 10-215

In quiltmaking, the term "crazy patchwork" ("crazy quilt" for short) refers to piecing together randomly shaped sections of fabric and embellishing them with embroidered and appliquéd motifs. When making this crazy quilt, Delphia Haskins chose plain and printed cotton fabrics for her quilt blocks, rather than the typical silk, satin and velvet, and decorated each of the forty-two blocks with a different appliquéd figure. Human figures — a mother and child, a man, and an image of Abraham Lincoln — were interspersed with common barnyard animals as well as less familiar creatures such as moose, mountain lions, camels and giraffes. The motifs were probably adapted from popular magazines and books.

At the time this quilt was made, Delphia Haskins and her husband, Samuel, were living in Rochester, Vermont, and operating a tailoring business with their seven daughters. It is likely that Delphia made this quilt as a wedding present for her daughter, Ada, who was married in 1877.

Detail of the quilt.

Sunflower Stalks Quilt

Carrie M. Carpenter (1835-unknown)

Northfield, Vermont

About 1885

Cotton appliqué

L. 99"; W. 100"

Gift of Ethel Washburne, 1987

1987-19; 10-651

The tall sunflowers appliquéd and quilted on this bedcover are an example of the Aesthetic Movement vocabulary made popular in America through the writings of the English reform designer Charles Eastlake. The flowers, petals, and stems were appliquéd (sewn) onto the white background, which is richly textured with hand-quilted stitches. The maker inscribed her name on the back of the quilt, "Carrie M. Carpenter."

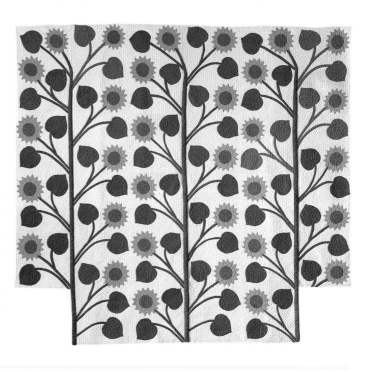

Chamber Table

Inscribed in pencil: "Elizabeth Paine
Lombard Feb 1816" on the drawer
front

Bath, Maine

1816

Painted wood

H. 33 1/2"; W. 32 1/4"; D. 16 3/4"

Purchased from Sanger Atwill, 1960

1960-85; 3.6-61

The painted decoration on this table includes landscapes, shells, seaweed, a basket of fruit, birds, and leaves. Written on the top of the table is a poem titled "Hope," by an author named Pope (not Alexander Pope), about whom we have found no record.

At the end of the 18th century, ornamental painting became, like sampler making, a part of the curriculum in girls' schools. Such skills were thought to be necessary to the education of an accomplished woman. Elizabeth Lombard decorated the table shown here when she was eighteen.

This sort of painting is ultimately derived from the European decoration seen in the work of English neoclassical designers and architects.

Top of table

Side of table

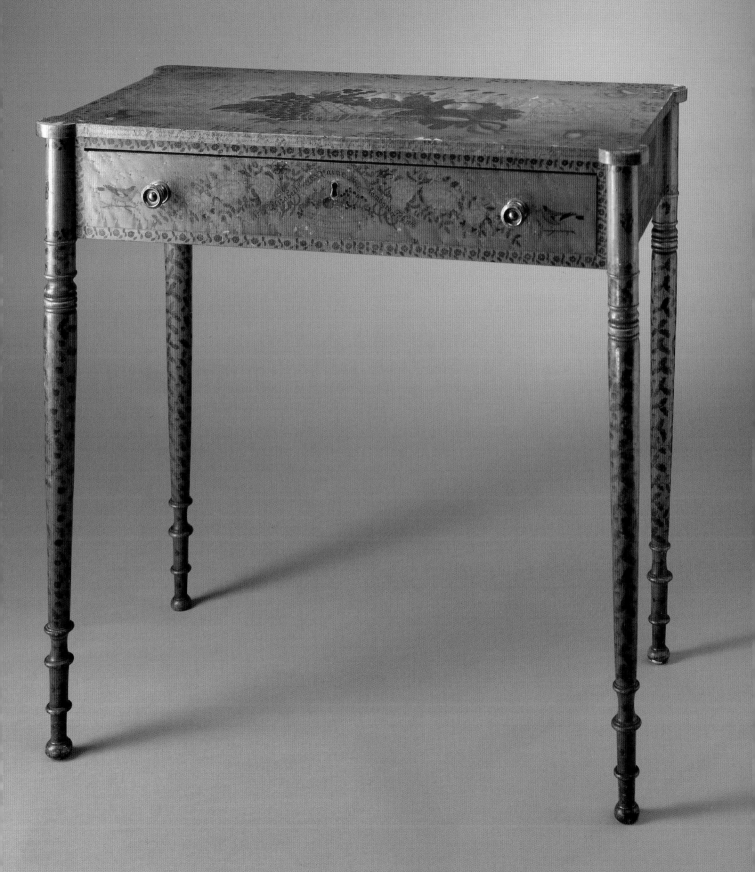

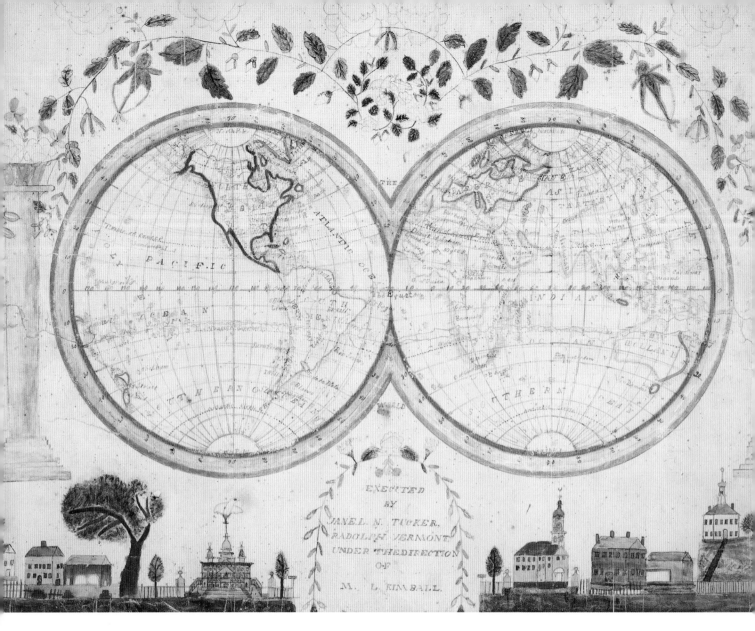

EXECUTED
BY
JANE L. N. TUCKER,
RADOLPH, VERMONT
UNDER THE DIRECTION
OF
M. L. KIMBALL.

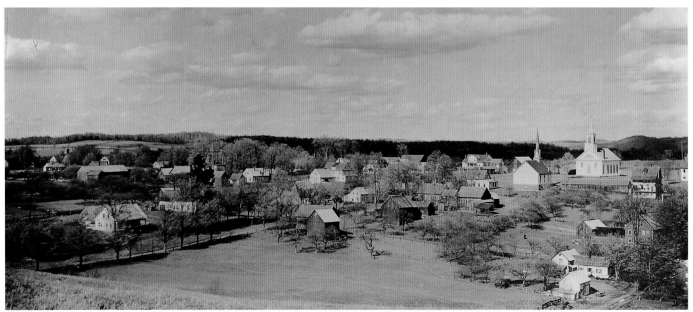

View east from Sunset Hill, Randolph. Buildings in the watercolor can be seen in this photograph. From the collections of Vermont Historical Society.

Map of the World

Jane Lory Norton Tucker (1819-1840)
Randolph, Vermont
About 1830
Watercolor
H. 25 1/2"; W. 30 1/2"
Purchased from Edith Halpert,
Downtown Gallery
27.2.6-4

Girls and young women were taught art through paintings like this and mourning pictures, like the one on page 84. Here the watercolorist identified herself, "Executed by Jane L.N. Tucker," and the location, "Randolph, Vermont." She also named her teacher, "M. L. Kimball."

Teachers like Kimball usually provided images for students to copy, but Jane Tucker, an accomplished watercolorist, was also inspired by local scenery (see photo) and included recognizable images of the two Randolph, Vermont churches. These can be seen in the decoration at the bottom right of her watercolor.

Detail on the left.

Detail on the right.

***Birth certificate
for Isaac Lang***

Pennsylvania German fraktur

Maker unknown

Probably Berks County, Pennsylvania

About 1843

Ink and paint on paper

H. 14 3/4"; W. 19 1/2"

Purchased from Edith Halpert,

Downtown Gallery, 1954

27.13-7

The birth certificate was probably made by a Pennsylvania German school teacher, who would have had both the penmanship skills and the knowledge of German grammar necessary to create it. Works like this are often called "frakturs," a German word referring to a certain design in Gothic lettering. In America, fraktur came to refer to the style of decoration that, as in this document, suggests an illuminated manuscript.

The beginning of this document is in English: "Isaac Lang was born May the 6th, 1843, Christened August the 6th Son of Isaac Lang and Susanna the wife."

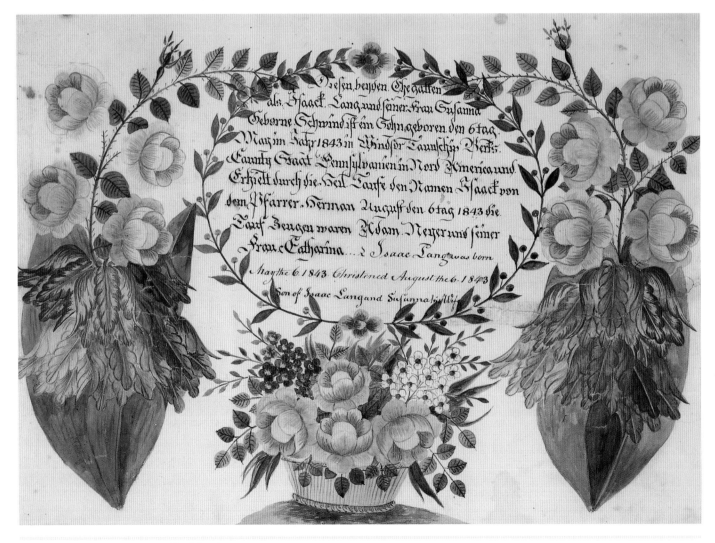

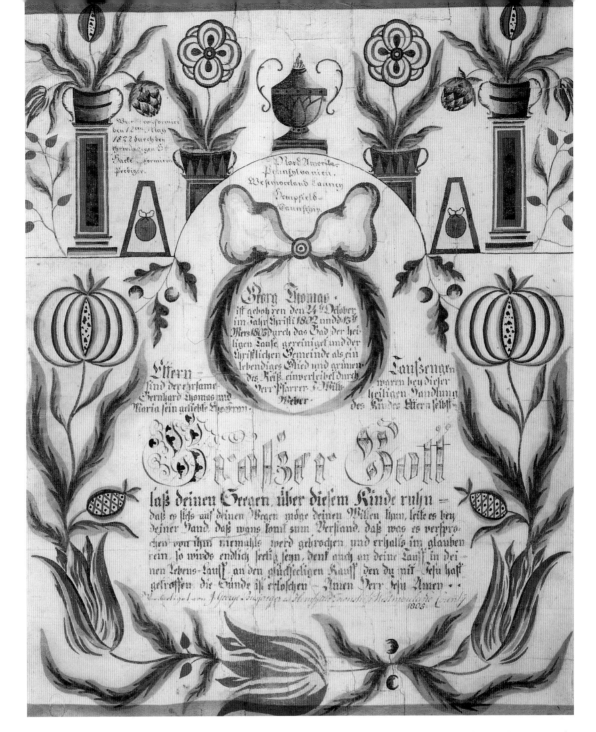

Birth certificate for Georg Thomas

Pennsylvania German fraktur

George Busjaeger (active 1815-1825)

Possibly Hempstead Township,

Westmoreland County, Pennsylvania

1805

Ink and paint on paper

H. 17 1/4"; W. 14 1/2"

Purchased from Edith Halpert,

Downtown Gallery, 1954

27.13-8

This sort of elaborately decorated birth certificate, made within the Pennsylvania German community, is often called a "fraktur," a German word originally used to describe a type of Gothic lettering.

Although seen today as a finished work of art, this fraktur and others like it were actually works in progress, as important milestones in an individual's life, such as baptism, confirmation, marriage — and finally his or her death — were included.

It is only in recent years that ice-spearfishing decoys have come to be recognized as fine examples of American folk sculpture. For thousands of years Native Americans have spearfished for trout, pike, carp and numerous other species. Today ice-spearfishing, particularly on the frozen lakes of the Midwest and the Northeast, is a widely enjoyed sport.

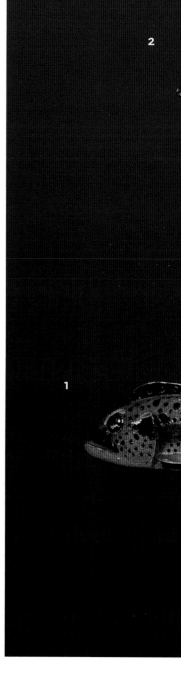

1 *Trout*
Fish decoy
Oscar Peterson (1887-unknown)
Cadillac, Michigan
About 1930
Carved and painted wood, metal
H. 1 3/4"; W. 9"; D. 2"
Gift of Steven and Nevine Michaan, 1996
1996-48.17; FD33-25

Oscar Peterson, of Cadillac, Michigan, began making decoys as a boy and continued for at least fifty years. It has been estimated that he made between ten and fifteen thousand and sold many of them to tourists, though today probably only about 10% still exist.

Peterson's work is considered the finest of its type and is still avidly collected. Not only are his decoys striking in appearance but they have a reputation for being good for fishing.

2 *Unidentified*
Fish decoy
Art Repp
St. Clair Flats, Michigan
About 1940
Carved and painted wood, metal
H. 1/2"; W. 3"; D. 9/16"
Gift of Steven and Nevine Michaan, 1996
1996-48.7; FD33-15

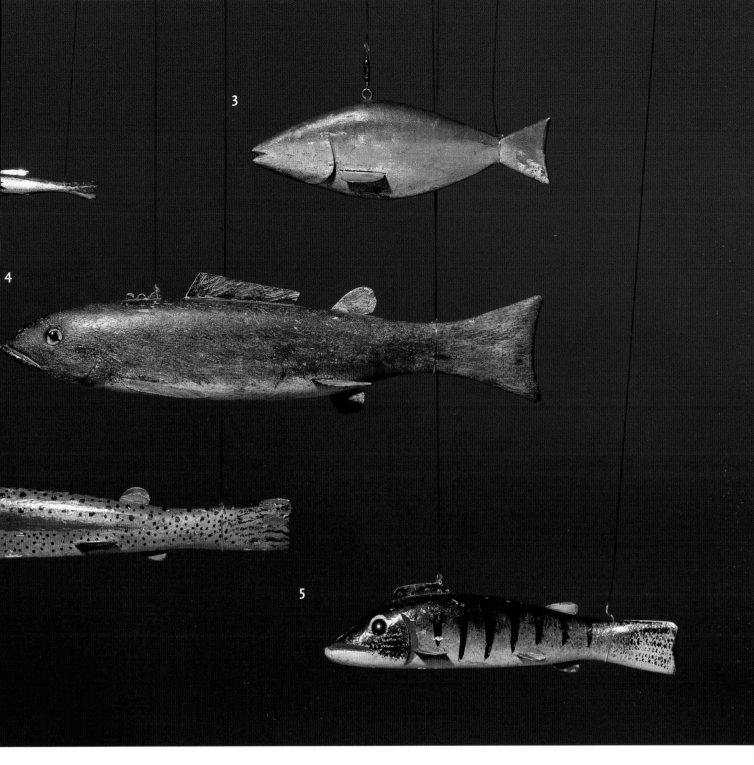

3 *Unidentified*

Fish decoy

Manfred Caughell

Marine City, Michigan

About 1930

Carved and painted wood, metal

H. 2 1/8"; W. 6"; D. 1 7/8"

Gift of Steven and Nevine Michaan,

1996

1996-48.9; FD33-17

4 *Bass*

Fish decoy

Abraham de Hate

Mount Clemens, Michigan

1950s

Carved and painted wood, metal

H. 2 5/16"; W. 10 3/4"; D. 3 1/2"

Gift of Steven and Nevine Michaan,

1996

1996-48.1; 17; FD33-9

5 *Perch*

Fish decoy

Oscar Peterson (1887-unknown)

Cadillac, Michigan

1930

Carved and painted wood, metal

H. 1 7/8"; W. 7"; D. 1 3/4"

Gift of Steven and Nevine Michaan,

1996

1996-48.14; 17; FD33-22

**A. Elmer Crowell,
Decoy Maker**

Trade sign

Probably by Anthony Elmer Crowell

(1862-1951)

East Harwich, Massachusetts

About 1912

Painted wood

H. 21 3/4"; W. 17 1/4"; D. 1 1/2"

Purchased from Wallace H. Purman,

East Orleans, Massachusetts, 1966

1966-233; FT-158

Crowell is considered one of the most gifted American decoy makers. This sign hung in East Harwich, Massachusetts, outside his shop, which he opened in 1912 when he began making decoys full time. Crowell worked without assistance, both carving and painting his decoys. He made three grades of birds; his best-grade decoys were carved with their wings lifted up from their bodies, as in his *Black Duck.*

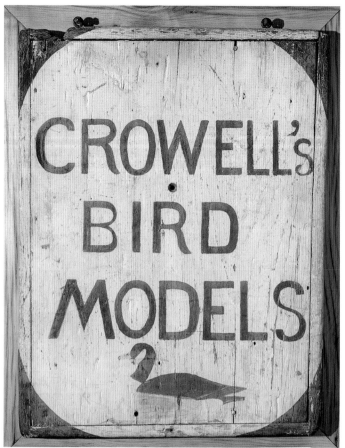

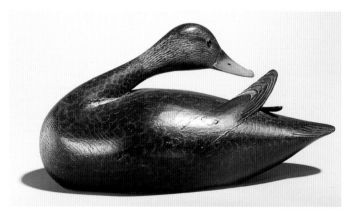

Black Duck

Decoy

Carved by Anthony Elmer Crowell

(1862-1951)

East Harwich, Massachusetts

About 1920

Carved and painted wood

H. 7 1/2"; W. 16 1/2"; D. 5 3/4"

FD4-43

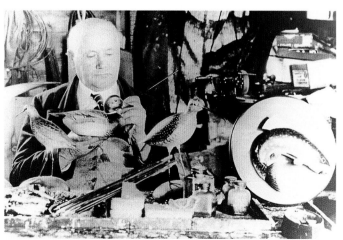

Apart from a few drawing classes, Crowell, who began making decoys when he was ten, was largely self-taught. This is an example of the best of his three grades of decoys. It was originally used for luring birds while hunting along the northeast Atlantic coast.

The detailing of the tail feathers and the bird's finely shaped head are distinctive of Crowell's carving. In 1914 the Boston Sunday Globe called his pieces the "best decoys produced by hand in any workshop."

A. Elmer Crowell in his East Harwich workshop, about 1930. Photo courtesy of Heritage Plantation, Sandwich, Massachusetts. 1991.16.8.

Curlew (right)

Decoy

Mason Decoy Factory, Detroit, Michigan

About 1900

Carved and painted wood, glass eye, metal

H. 16"; W. 14"; D. 6"

Gift of Richard H. Moeller, 1956

FD19-263

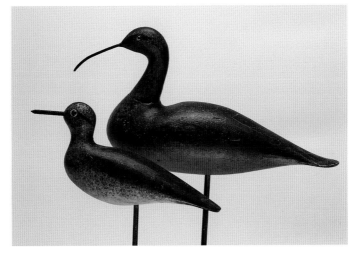

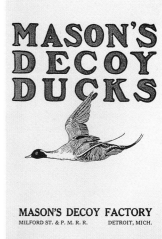

Mason's Duck Decoys, *Mason's Decoy Factory, Detroit, Michigan. Cover of the firm's catalog. Shelburne Museum Archives.*

Factory-made decoys were produced to meet the demand of market gunners who hunted game in large quantities to supply the growing urban markets that developed after the Civil War. With the growth of the railroad systems in the 19th century, birds could easily and quickly be transported to the cities for food. Feathers were also in high demand for the latest millinery fashions.

Mass production led to the standardization of forms, which distinguishes factory-made decoys from those made by professional carvers like Crowell, whose *Black Duck* is shown on the opposite page. Nonetheless, elegant decoys like this one appeal to folk art collectors. This form from Mason's is considered one of the factory's best products.

The factory was founded by William James Mason, a first-generation immigrant from Ireland. He began to carve and sell decoys in 1889 and by 1903 had established a 1,000-square-foot manufactory. On the first floor the basic forms were cut on band saws. The bodies were then further shaped on the tracing lathe, and the heads were finished by hand. The painting was done on the floor above.

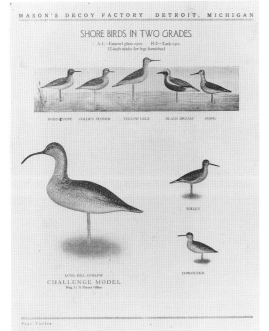

Snipe (above left)

Decoy

Mason Decoy Factory, Detroit, Michigan

About 1900

Carved and painted wood, glass eye, metal

H. 4 1/4"; W. 10 1/2"; D. 3"

Gift of Richard H. Moeller, 1956

FD19-36M

This decoy of a snipe, a game bird hunted on the Atlantic coast, is one of the Mason Factory's A-grade productions. His shore bird decoys came in two grades, A and B, which were illustrated in the factory catalog (see illustration). This is a rare example of a snipe decoy; though others were made, few have survived.

"Shorebirds in Two Grades." Catalog page from Mason's Decoy Factory, Detroit, Michigan. Shelburne Museum Archives.

Gallery of Folk Art

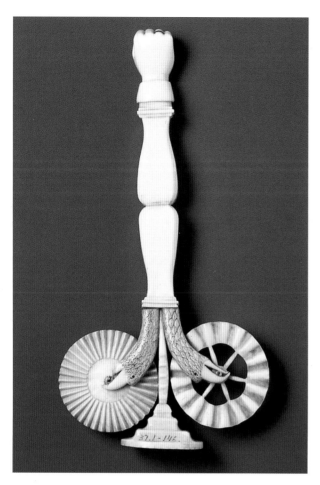

Crimper:
Double Eagle
Scrimshaw
Maker unknown
Mid-19th century
Carved, incised ivory colored with
red wax; brass and silver
H. 7"; W. 4"; D. 1 1/2"
Gift of George G. Frelinghuysen, 1964
1964-79; 37.1-146

Pie crimpers (used to cut, press and pierce pie pastry) were a common form of scrimshaw carved by sailors on whaling voyages for their families at home. This example, however, is unusually elaborate with two different, patterned wheels, eagle heads and hand.

Although Mrs. Webb did not collect it, scrimshaw was bought and sold as folk art beginning in the early 20th century. Most of the scrimshaw at the museum was given four years after Mrs. Webb's death by her nephew, George G. Frelinghuysen.

Swift or
Wool Winder
Scrimshaw
Maker unknown
Mid-19th century
Turned and incised whale ivory and
bone; wood padded with velvet
Base: H. 6 3/4"; W. 8 1/2; D. 8 1/2"
Overall (assembled): H. 18"; W. 18"
Gift of George G. Frelinghuysen, 1964
1964-1, 37.1-122

Swifts were used to measure quantities of yarn, which is wrapped around the winder and then wound off as skeins (a measure which varies according to the type and use of the wool). The spools at the base are for storing yarn.

The basket ribs of this swift were shaped from the whale's jawbone, and teeth were used for the yarn holder, lower clamp and spool holders. The center shaft was turned from a long walrus tusk.

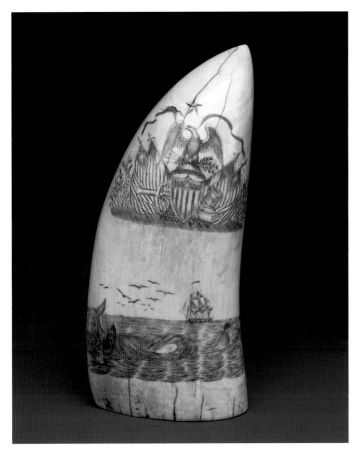

Sperm Whale's Tooth

Scrimshaw

Maker unknown

Mid-19th century

Incised and inked ivory

H. 7 3/4"; W. 4"; D. 2 1/2"

Gift of George G. Frelinghuysen, 1964

1964-79; 37.1-148

In the mid-1930s this whale tooth, with its image of George Washington and the emblems of the United States of America, was judged of outstanding artistic merit and therefore was included in the Index of American Design. This was the federal government's Depression Era project to record for posterity the finest examples of American craftsmanship.

The image of George Washington was taken by the unidentified scrimshaw carver from a popular print by Nathaniel Currier, *Washington's Reception by the Ladies*, 1845.

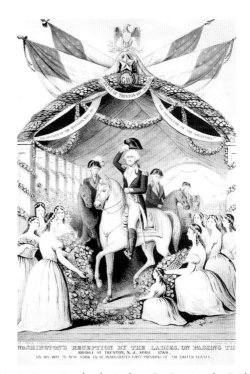

Washington's Reception by the Ladies, On Passing the Bridge at Trenton, N.J. April 1789 On his Way to New York to be Inaugurated First President of the United States. *Hand-colored lithograph, 1845. Nathaniel Currier Publisher. Shelburne Museum.*

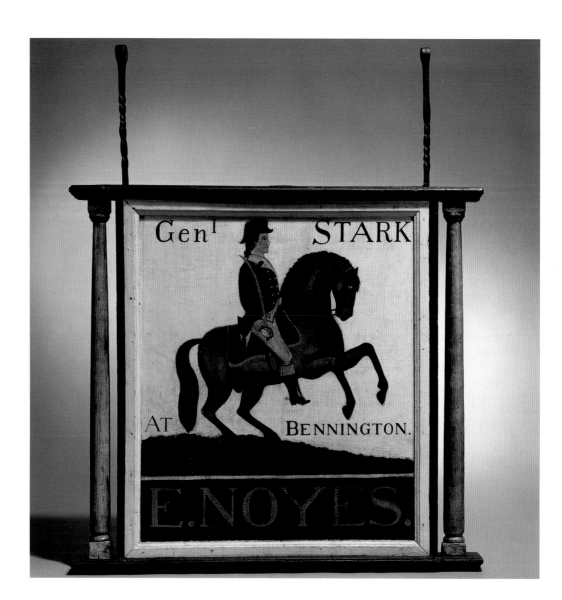

E. Noyes

Trade sign

Maker unknown

Mid-19th century

Painted wood

H. 30"; W. 33 3/4"; D. 3 1/4"

FT-51

Taverns and inns traditionally were named for great historical figures, as English pubs often still are. General Stark was a famous Revolutionary War general who fought in the Battle of Bennington on August 16, 1777.

Eugene Noyes owned stores in Hampton, New Hampshire, and Amesbury, Massachusetts. The existence of this sign indicates that he may have owned an inn or tavern, but no documentation to the effect has been found.

View of opposite side

Charles Banner

Trade sign

Maker unknown

1806

Carved, turned and painted wood

H. 50 1/2"; W. 31"; D. 3"

Purchased from the estate of

Natalie K. Blair, 1954

FT-72

This sign's bold shape and painted decoration have significant artistic merit, and it is a rare survivor from the first decade of the 19th century. Shelburne Museum founder Electra Webb bought the sign in 1954 from the estate of the ambitious collector Natalie K. Blair (1887-1952). Mrs. Blair is best remembered for her gift of magnificent American furniture to the Metropolitan Museum of Art in New York. In 1927 she lent this tavern sign to the Metropolitan for an exhibit of early American architectural fragments.

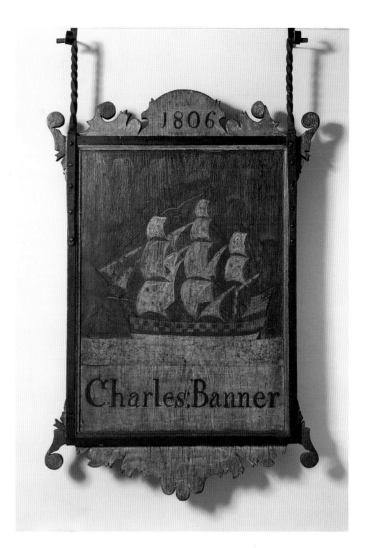

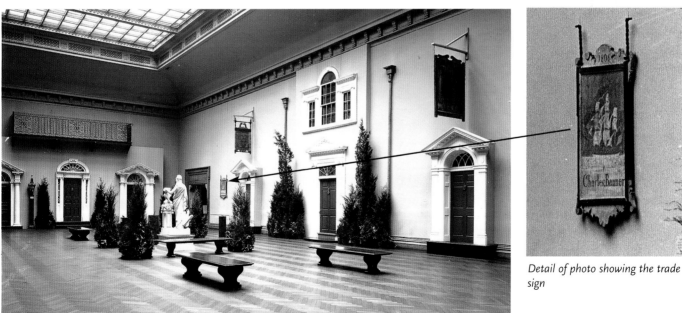

Detail of photo showing the trade sign

Charles Banner *trade sign in* Architectural Details from the Exteriors of Early American Houses *at the Metropolitan Museum of Art, 1927. Photograph courtesy of the Metropolitan Museum of Art.*

Horse, Tiger, and Giraffe

Carousel figures

Carved by Daniel Muller (1872-1952)

Gustav Dentzel Carousel Company

(1867-1928), Philadelphia,

Pennsylvania

About 1902

Carved and painted wood

Tiger: H. 53"; W. 80"; D. 32"

Horse: H. 59"; W. 65"; D. 12"

Giraffe: H. 66 1/2"; W. 53"; D. 12"

Purchased from the antiques deal-

ers Jones & Erwin, 1952

FC-7

Master carver Daniel Muller's tiger, giraffe, and horse are three of forty-four superb animals from a complete carousel made by the Dentzel Company and now at the museum. During a fifty-year period beginning in the 1870s, the Dentzel Carousel Company made some of the finest carousels. All of the figures from this carousel survive with their original paint, a rare occurrence as carousels were often repainted as part of routine maintenance.

The museum's carousel was originally built a hundred years ago for the Sacandaga Amusement Park at the end of the rail line in Northville, New York. It was owned by the Fonda, Johnstown and Gloversville Railroad Co. Railroads often established such parks to attract passengers.

In Dentzel's large workshop, several carvers worked on different parts of an animal, but the master carver in these cases, Daniel Muller, always carved the head and did much of the detailed finishing work. Daniel Muller was the most gifted of Dentzel's carvers and designed and drew the patterns for many figures.

In 1952 when the Dentzel carousel was first offered to Mrs. Webb for the museum, she initially feared a carousel (any carousel) might not be good enough for the collection. But, as she later related, she had a dream about her family enjoying a carousel ride, and purchased it so that museum visitors could enjoy the carousel, which they do, at least visually, because it is not ridden.

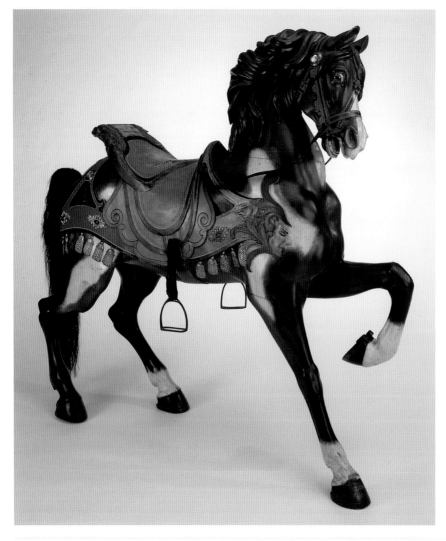

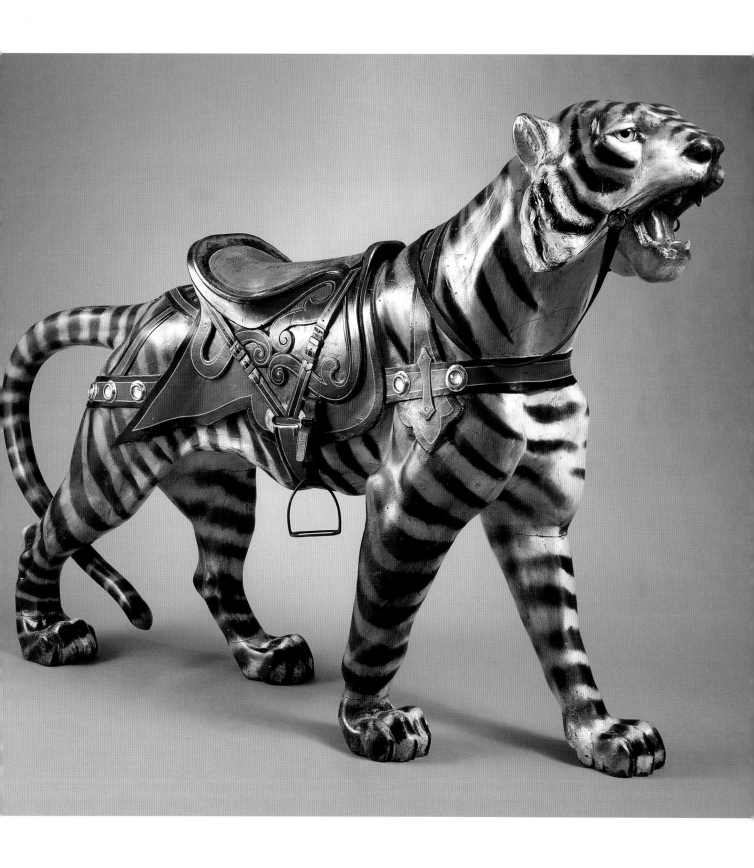

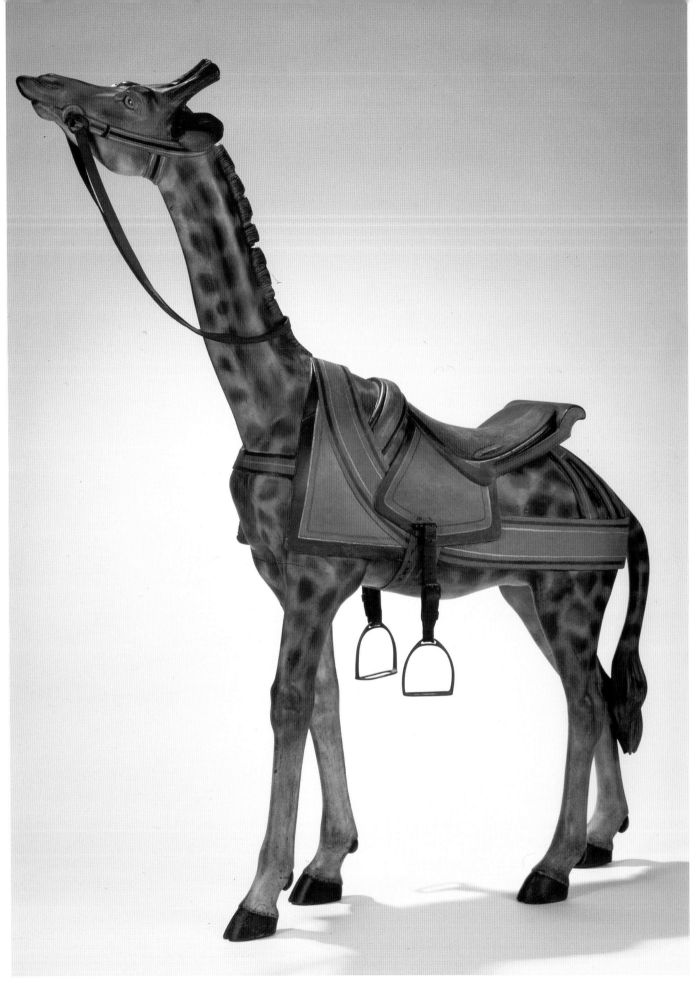

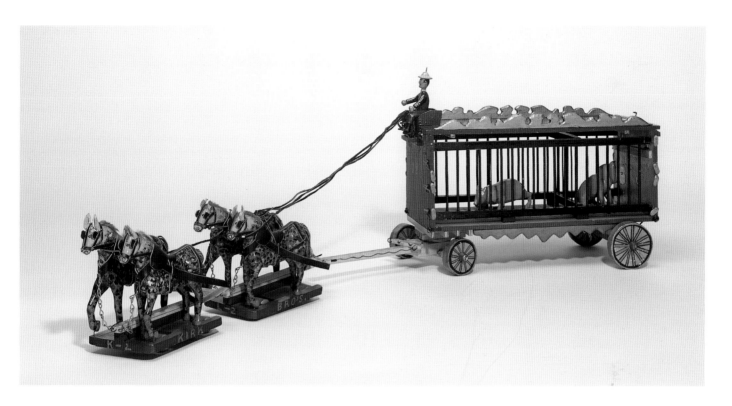

Miniature Lion Wagon

Kirk Bros. Circus

Edgar Decker Kirk (1891-1956)

Harrisburg, Pennsylvania

Made between 1910-1956

Carved and painted wood

H. 25"; W. 10 3/4"; D. 8 1/4"

Gift of Richard and Joy Kantor, 1981

1981-30; 56-56.2

This wagon is part of the museum's four thousand-piece miniature circus, carved and painted by Edgar Kirk in his spare time while working as a brakeman for the Pennsylvania Railroad (see photo). It took him forty years — most of his adult life. The name, "Kirk Bros. Circus," probably is meant to suggest the Ringling Brothers Circus.

During the summer months Kirk set his animals and acrobats in his yard for the neighborhood children to play with. The minute details in his carvings capture the whimsy of a circus. He carved from memory, without photographs, his only tools a treadle jigsaw and a penknife. He bought paint and nails, but used scrap lumber.

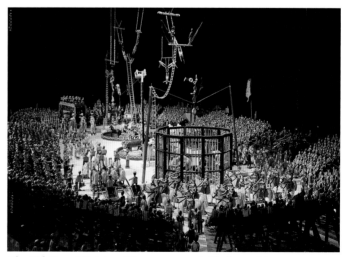

The Kirk Bros. Miniature Circus, 1910-1956. Shelburne Museum.

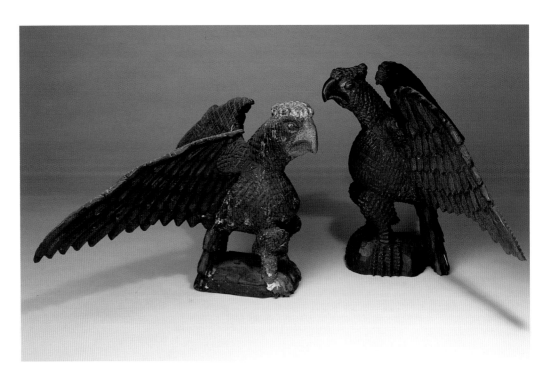

Eagle

Carving

Wilhelm Schimmel (?-1890)

Late 19th century

Carved and painted wood

H. 17"; W. 39 1/2"; D. 9"

Purchased from George McKearin

FE-41

Eagle

Carving

Wilhelm Schimmel (?-1890)

Late 19th century

Carved and painted wood

H. 14 1/2"; W. 26"; D. 21 1/2"

Gift of Electra Webb Bostwick, 1952

1952-231; FE-44

Eagle

Carving

Wilhelm Schimmel (?-1890)

Late 19th century

Carved and painted wood

H. 10 1/2"; W. 13 1/2"; D. 9"

Gift of the Harry T. Peters family, 1982

1982-5.507b; FE-89

In the 1920s, Wilhelm Schimmel was one of the first 19th century folk art carvers to be rediscovered and his work quickly became celebrated for its expressive qualities. His life has almost become legend; he was an itinerant artist in the area of Carlisle, Pennsylvania, where he habitually exchanged his bird carvings for money, food or drink. The feathers on most of Schimmel's work are cross-hatched in the stylized manner visible in these examples.

In the 1950s Electra Webb made her Schimmel birds part of a striking ensemble arranged in one of the rooms of the museum's 18th century tavern building, Stagecoach Inn. She grouped them on specially made brackets against a patterned wallpaper (see photo).

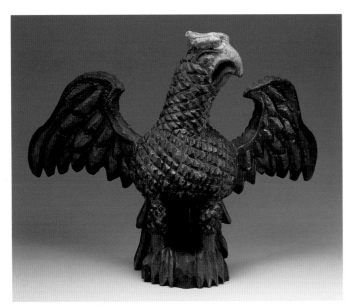

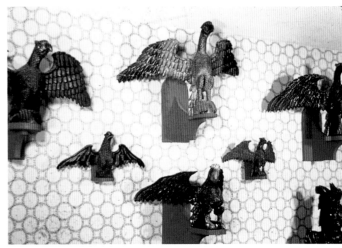

Stagecoach Inn Installation, Shelburne Museum, about 1955.

Parrot

Carving

Wilhelm Schimmel (?-1890)

Late 19th century

Carved and painted wood

H. 7 1/2"

Gift of Electra Webb Bostwick, 1952

FE-43a

Parrot

Carving

Wilhelm Schimmel (?-1890)

Late 19th century

Carved and painted wood

H. 7 1/2"

Gift of Electra Webb Bostwick, 1952

FE-43b

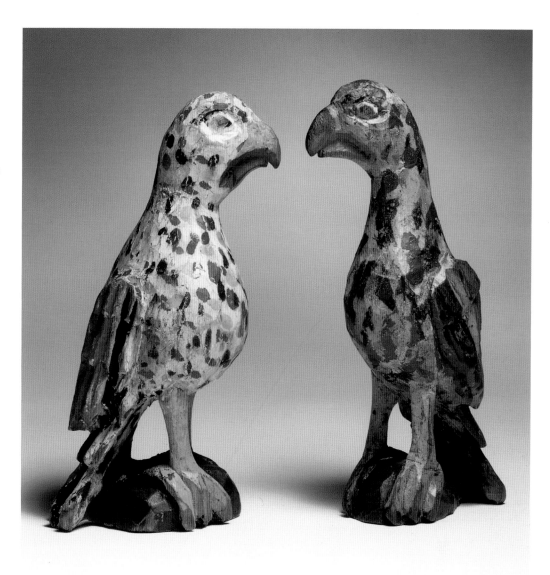

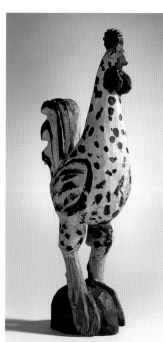

Rooster

Carving

Wilhelm Schimmel (?-1890)

Late 19th century

Carved and painted wood

H. 14"

Purchased from John Kenneth

Byard, 1958

FM-94

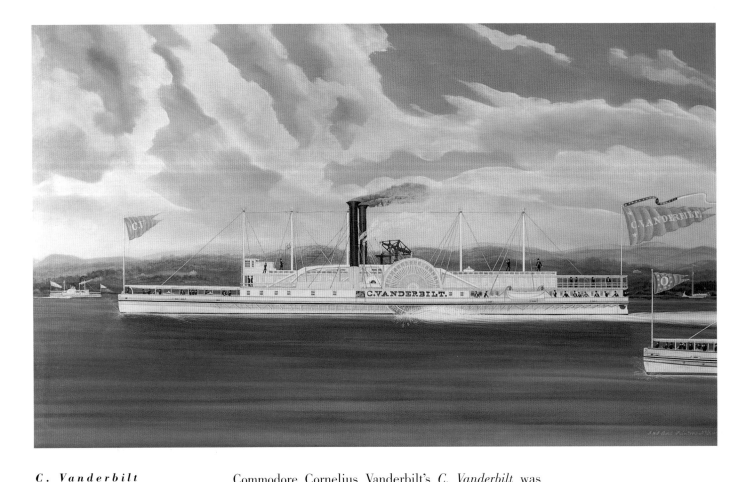

C. Vanderbilt

John (1815-1856) and James Bard
(1815-1897)

New York City

1847

Oil on canvas

H. 32"; W. 51"

Purchased at auction, 1987

1987-46; 27.1.4-090

Commodore Cornelius Vanderbilt's *C. Vanderbilt* was launched on the Hudson River in 1847, and expected to be the fastest boat of her day. Vanderbilt published a challenge "for any sum from $1,000 to $100,000," to any boat that could beat her. George Law took up the gauntlet for $1,000 and won with a boat named the *Oregon*. During the race the *Oregon* ran out of fuel, but, to keep the engines turning, the crew burned all her lavish interior fittings and furniture valued at $30,000. In this painting, the *Oregon* (to the right) is shown trailing the *C. Vanderbilt*, to give the impression, wrongly, that Vanderbilt's steamboat won. The Bard brothers painted several passengers looking at their pocket watches to check the timed run.

Cornelius Vanderbilt, who made his first fortune owning steamboats on the Hudson River, was the great-great-grand-father of Shelburne Museum founder Electra Webb's husband, J. Watson Webb.

Born in New York, the Bard twins began painting at the age of twelve. They painted with each other until 1849 when John left the partnership. James then painted alone until the 1890s.

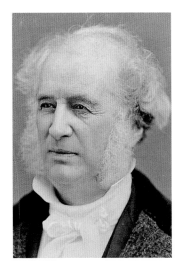

Cornelius Vanderbilt (1794-1877). Shelburne Farms Collections, Shelburne, Vermont.

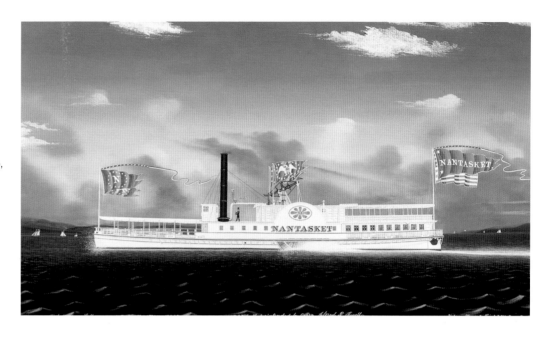

Nantasket

James Bard (1815-1897)

New York City

Oil on canvas

1857

H. 35 1/2"; W. 57 3/4"

Purchased from The Old Print Shop,

New York City, about 1950

27.1.4-7

The Nantasket, built in New York City, was launched in March of 1857 for Boston Harbor service, and sank in 1924.

Steamboat portraits like this one were usually commissioned by owners, captains, builders, and engine makers, and often hung in wharfside offices. In New York City, many artists specialized in boat portraits, but James Bard seems to have had a virtual monopoly on pictures of sidewheeler steamboats. He lived and worked on Perry Street, in Greenwich Village, a block from the Hudson River. Early in his career James painted with his brother John, but this work was painted in 1857 after John left the partnership. Today there are about four hundred known pictures from an estimated three thousand originally produced.

After James's death, the paintings were largely forgotten until the 1920s, when steamboat aficionados and early lovers of American folk art began to collect them.

Our Flag is There

Artist unknown

19th century

Oil on canvas

H. 15"; W. 19 1/2"

Purchased from Maxim Karolik, 1957

27.1.4-68

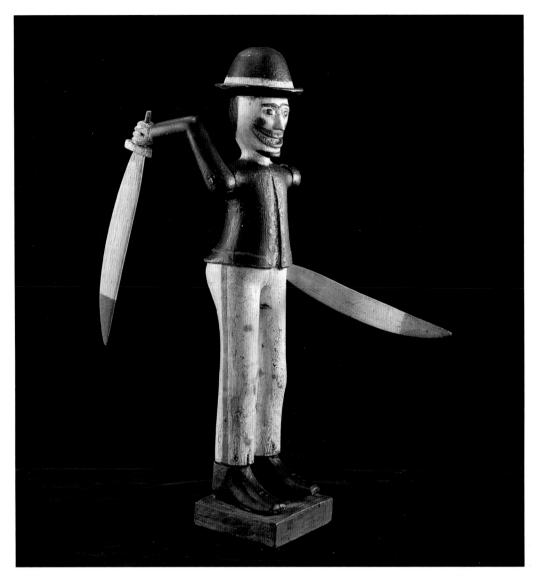

Swordsman
Whirligig
Maker unknown
Late 19th century
Carved, painted wood
H. 17 1/2"; W. 5"; D. 3 3/4"
FW-43

Whirligigs are made primarily for the enjoyment of the visual effect as the wind blows their moving parts around. In this one, a much reproduced form, the wind made the arms and swords twirl.

Squirrel Cage
Maker unknown
About 1900
Carved and painted wood
H. 26"; W. 24"; D. 8 1/2"
FM-53

This was probably made as a child's toy. A squirrel in the treadmill worked the up and down saws of the four jointed figures. On either side of the treadmill are nesting boxes.

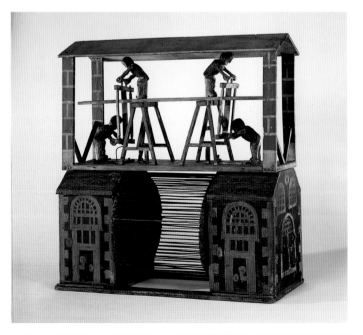

Lift-Top Chest with Drawer

Maker unknown
Early 19th century
Possibly from New Hampshire
Painted wood
H. 28 1/2"; W. 37"; D. 16 1/4"
Purchased from Ralph M. Meyer
3.4-42

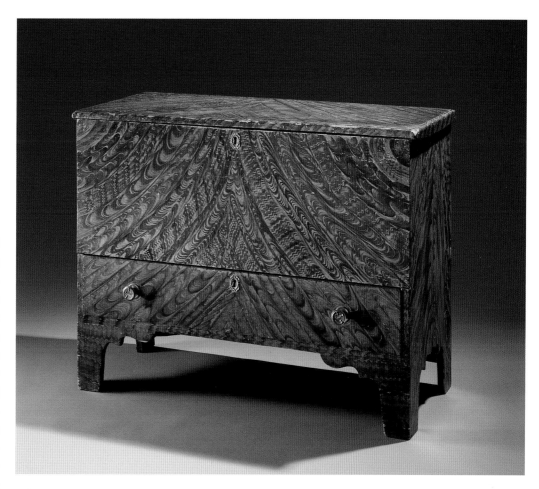

While the lift-top chest is an old form dating back to the Renaissance, the colorful surface makes this a very stylish piece. Brown and yellow paints have been used boldly to create the impression of large drapery folds or fancifully grained wood. Thus an urban neoclassical style of decoration transforms a simple, functional piece of rural New England furniture into a handsome work.

Jack Tar

Trade sign
Maker unknown
Mid-19th century
Carved and painted wood
H. 61"; W. 27"; D. 24 1/4"
Gift of Dr. L. J. Wainer, 1962
1962-24; FM-121

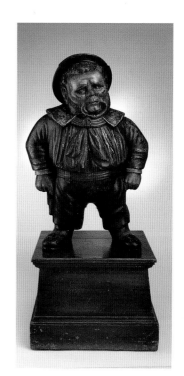

The sailor's hat, waterproofed with tar or paint, gives the ordinary sailor the nickname "Jack Tar." This image of Jack Tar appeared after 1841, when the U.S. Navy regulated its uniforms for the first time. The dress uniform for coming ashore, as in this figure, included an open jacket, neckerchief, black shoes, and a black, brimmed hat.

This *Jack Tar* was once a trade sign outside a San Francisco ship chandler's shop, which sold navigational instruments and naval supplies. It later stood outside a cigar store in San Jose, California.

Fruit on Marble

Artist unknown

About 1850

Oil on canvas

H. 27 1/2"; W. 33 1/2"

Purchased from The Old Print Shop, New York City, 1954

1954-474.1 (A); 27.1.3-1

Still life painting in America flourished in the mid-19th century when paintings like this one were sometimes copied from prints or "how to paint" manuals. Many still lifes share a similar composition of a large central bowl filled with apples or pears balanced on either side with other fruits. The inclusion of watermelons suggests this is an American painting; watermelons rarely appear in 19th century European paintings and were considered a uniquely American fruit. The unknown artist's highly stylized use of color and line gives the painting its unique character and makes it one of the most highly prized folk art pictures in the museum's collection.

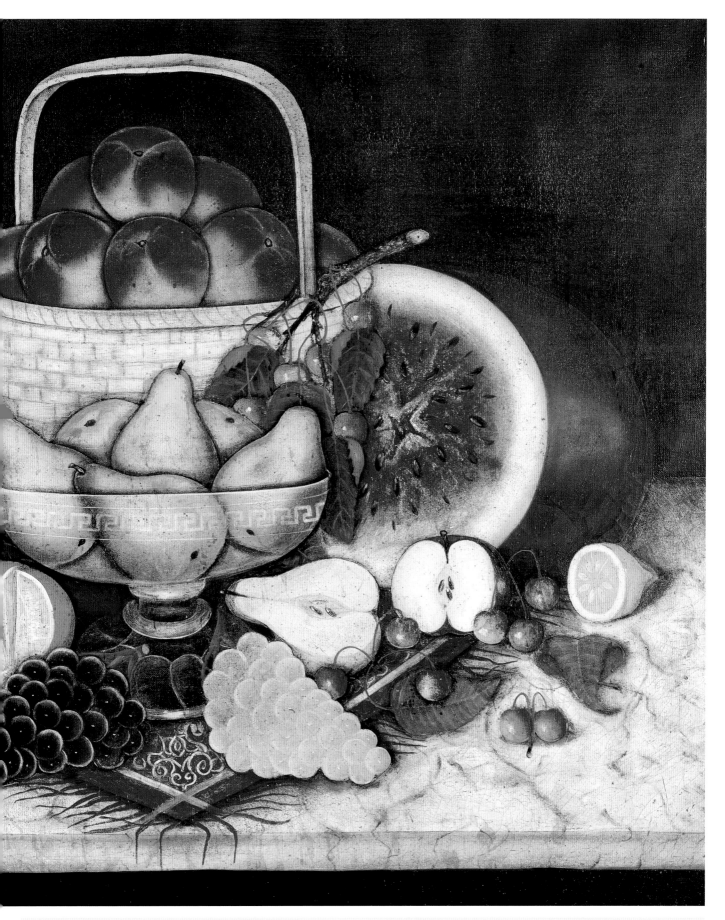

Suffragettes Taking a Sleigh Ride

Artist unknown

Oil on canvas

1870-1890

H. 29 1/4"; W. 45 1/2"

Purchased from Maxim Karolik, 1957

1957; 27.1.5-25

These twenty-two women are most likely traveling to a rally in support of women's suffrage. Suffragettes were the target of ridicule in prints and cartoons, and perhaps the artist based this painting on one of these images. Despite the patriotic symbolism of the eagle and the sleigh called the *Constitution*, the women pass unnoticed through an everyday scene. Only the African-American man, who also struggled for freedom at this time, acknowledges them.

The campaign for women to gain the right to vote was led by Susan B. Anthony and Elizabeth Cady Stanton who formed the National Woman Suffrage Association in 1869. Many states granted suffrage in 1890, but the 19th amendment, giving women the right to vote, was not passed until August 26, 1920. Electra Webb's mother, Louisine Havemeyer, was an ardent supporter of the movement. She raised money, spoke at rallies and, once, much to the consternation of her daughter, spent a night in jail for the cause.

Tinkle

Artist unknown

1883

Oil on academy board

Inscribed on verso: "April 1883";

Penciled on label: "Tinkle born

Febr 1881"

H. 23 3/4"; W. 18"

Purchased from Maxim Karolik

27.1.5-26

It has been said that in its composition, pose and gaze, this portrait of a cat resembles portraits of humans. Its collar and elaborate cushion symbolize its position in life. Born in February of 1881, Tinkle was two years and two months old when she sat for her portrait.

*Minnie from
the Outskirts of
the Village*

R. P. Thrall

1876

Oil on canvas

Signed: "By R. P. Thrall 1876"

H. 32 1/4"; W. 27 1/2"

Purchased from John's Antiques,

Ashley Falls, Massachusetts, 1960

1960-233; 27.1.5-9

When Mrs. Webb first saw the painting, she laughingly gave it this title. It is not known whether R. P. Thrall was an itinerant portrait painter or the cat's loving owner and an amateur artist.

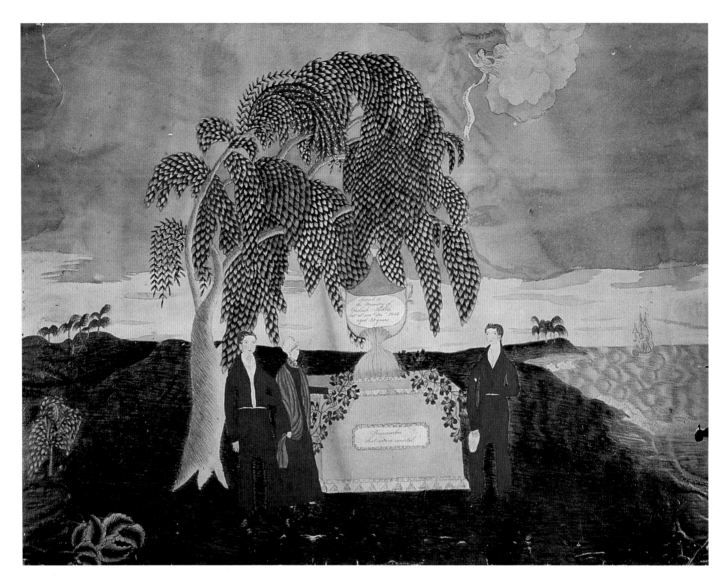

Mourning Picture
for Obadiah
Nichols

Maker unknown

About 1812

Watercolor on paper

Purchased from Edith Halpert,

Downtown Gallery, 1959

1959-165; 27.2.6-14

Today we continue to admire what early 20th century collectors called the naïveté of this amateur painting style which characterizes the work of school girls copying prints made by academically trained artists. Although no source for this watercolor has yet been identified, nonetheless the work reflects the standard painting manner of the period.

Although Electra Webb bought mostly folk sculpture from Edith Halpert at the Downtown Gallery, during the 1940s and 50s she also acquired from the gallery a small group of amateur paintings, including this one, and a handful of portraits.

Tooth

Trade sign

Maker unknown

19th century

Carved and painted wood

H. 24"; W. 12 1/4"; D. 11 1/2"

Gift of Julius Jarvis, 1962

1962-181; FT-139

The dentist who commissioned this sign to hang outside his office chose a striking oversized representation of his stock in trade — a tooth. It was probably carved in the shop of a professional sign maker who was accustomed to making a wide range of carved advertisements.

H. L. Adams Optician

Trade sign

Maker unknown

Late 19th century

Painted iron

H. 10 1/2"; W. 30"; D. 3/4"

Purchased from Roger Wentworth, 1964

FT-147

This sign, individualized with the optician's name, used to hang in Manchester Center, Vermont. It survives with its polychrome and gilding, a reminder that most of the folk art in the museum's collection was once vibrantly painted.

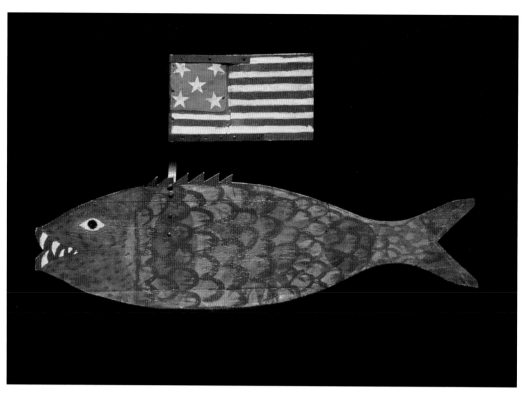

The fish and flag were probably part of a trade sign for an inn or tavern but survive today only as a fragment. Apart from its New York State origins nothing about the piece is known. It is however one of the landmark folk art objects of the Shelburne Museum. The simplicity of its design and the integration of its blues and reds make it a veritable masterpiece.

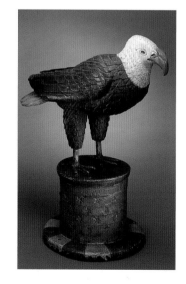

The original figure of "Uncle Sam" was invented during the War of 1812. Samuel Wilson (1766-1854), owner of a meat packing business in Troy, New York, began labeling crates of meat bound for the army with "U. S.," abbreviating United States. One of his employees mistakenly thought it stood for Uncle Sam, which was Samuel Wilson's nickname. The army perpetuated the error and before long soldiers were calling all government-issued supplies "property of Uncle Sam." They even saw themselves as Uncle Sam's men.

The first Uncle Sam illustrations appeared in New England newspapers in 1820. Over time, the image became more elaborate, and during Abraham Lincoln's term stars and stripes were added to the top hat.

This trade sign originated in Pittsburgh, Pennsylvania, where it is said to have been used outside a boarding house.

Side Chair

William Page Eaton

Inscribed: "W.P. Eaton"

1830-1850

Painted wood

H. 35 1/2"; W. 16 1/2"; D. 15 3/4"

Purchased from Richard Miller, 1991

3.3-444b

This is one of two fine chairs at the museum decorated by William Page Eaton. It was the rising popularity of "cottage" architecture, notably the designs for rural villas published by A. J. Downing in the 1840s, that led to the making of country style painted furniture like this chair.

Eaton used stencils to create the decoration. The stencils for this chair and his account books still exist in the collection of the Society for the Preservation of New England Antiquities, Boston, Massachusetts. Two other chairs from this set are in the collection of the Abby Aldrich Rockefeller Folk Art Center at Colonial Williamsburg, Virginia.

Mrs. Eunice Eggleston Darrow Spafford (1778-1860)

Noah North (1809-1880)

Signed on verso: "No 40 by N. North/

Mrs. Eunice Spafford/AE 55 years/Holley/1834"

1834

Oil on wood

H. 28"; W. 23 3/8"

Purchased from Robert McGuire, 1954

27.1.1-13

Noah North spent most of his life in western New York State working as a teacher, lumber dealer, and justice of the peace. In 1811, Eunice Eggleston Darrow moved to Clarendon, New York, after the death of her first husband, John Darrow. There she met her second husband, Mr. Spafford. The inscription "Holley" refers to the town in which Mrs. Spafford died in 1860.

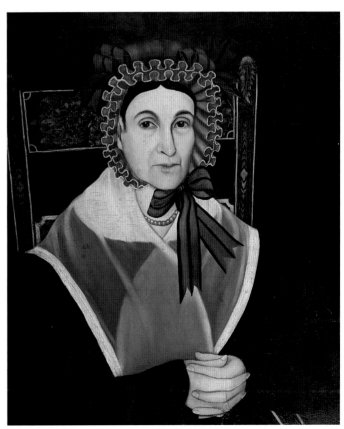

*To my dear friend
Electra Havemeyer Webb
Merry Christmas 1957,
Grandma, Moses.*

Old Home

Anna Mary Robertson (Grandma)
Moses (1860-1961)
Inscribed: "To my dear friend Electra
Havemeyer Webb
Merry Christmas 1957 Grandma
Moses"
1957
Oil on masonite
H. 21 1/2"; W. 17 1/2"; D. 2"
Gift to Electra Webb from the artist,
Christmas, 1957
27.1.2-25

Grandma Moses, one of America's best-known self-taught artists, began painting in 1927, at age sixty-seven, when her husband died. She painted scenes based on her life as a hired girl on a neighboring farm and then as a farmer's wife. She had her first work displayed in 1939 in a drugstore window in Hoosick Falls, New York, where art collector Louis Calder noticed it. Her first solo exhibit was in 1940 at the Galerie Saint Etienne in New York City. Grandma Moses visited the Shelburne Museum several times, and she and Mrs. Webb became friends.

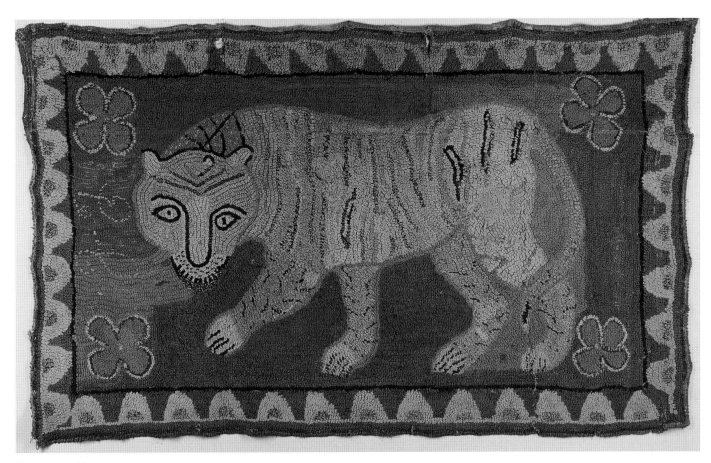

Bengal Tiger
Hooked rug
Signed: "C.C."
About 1820
H. 41 1/4"; W. 67"
Purchased from Ginsburg and Levy,
New York City, 1954
1954-647; 9-M-11

In the early 19th century hooked rugs were extremely common both as floor and bed coverings. (A bed rug appears on page 54).

This example is a hearth rug and its tiger design was probably inspired by a woodcut from Englishman Thomas Bewick's *The Quadrupeds*, published in Philadelphia in 1810.

Fourth of July
Hooked rug
Signed: "The 4th of July, all had a good time"
About 1940
Wool, cotton and nylon hooked on burlap ground
H. 37 1/2"; W. 45 1/2"
Gift of Mr. Fred MacMurray, 1973
1973; 9-M-48

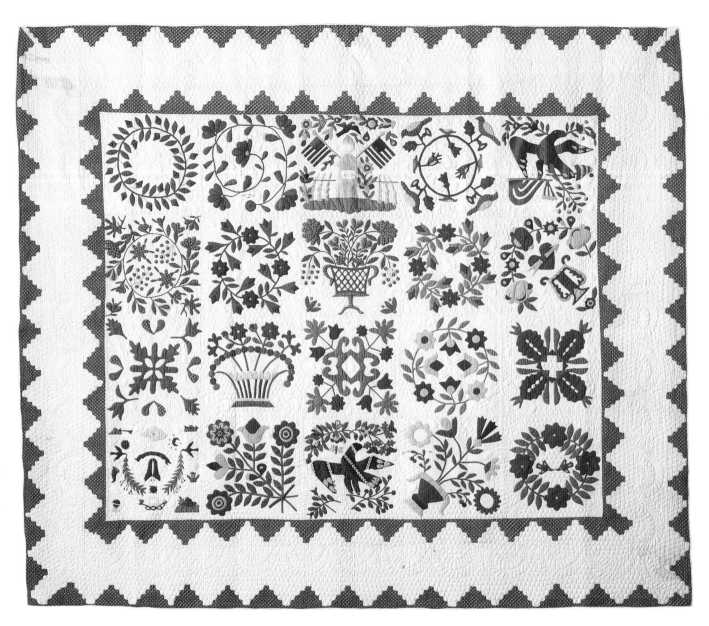

***Major Ringgold
Album Quilt***

Maker unknown

Baltimore, Maryland

1847-1850

Cotton appliqué

L. 93"; W. 110"

Purchased from E. Haydn Parks,

Buffalo, New York, 1959

1959; 10-330

Baltimore-style album quilts, made by professional seamstresses and skilled amateurs alike, are known for the excellence of their craftsmanship, their use of elegant fabrics, and the overall harmony of their design. In the mid-19th century, Baltimore was the second-largest port in America. Quiltmakers took advantage of the wide variety of printed textiles available and skillfully used them in distinctive multi-layered appliqué, such as that shown here. The two eagle blocks and the monument at top center illustrate the use of the popular rainbow fabric to provide shading and texture to the images.

The quilt commemorates the military hero Major Samuel Ringgold. He was born in Washington County, Maryland, in 1800 and died on May 11, 1846, from a cannon ball wound received at the Battle of Palo Alto in the Mexican-American War. His body was returned to Baltimore and buried with military honors on December 22, 1846.

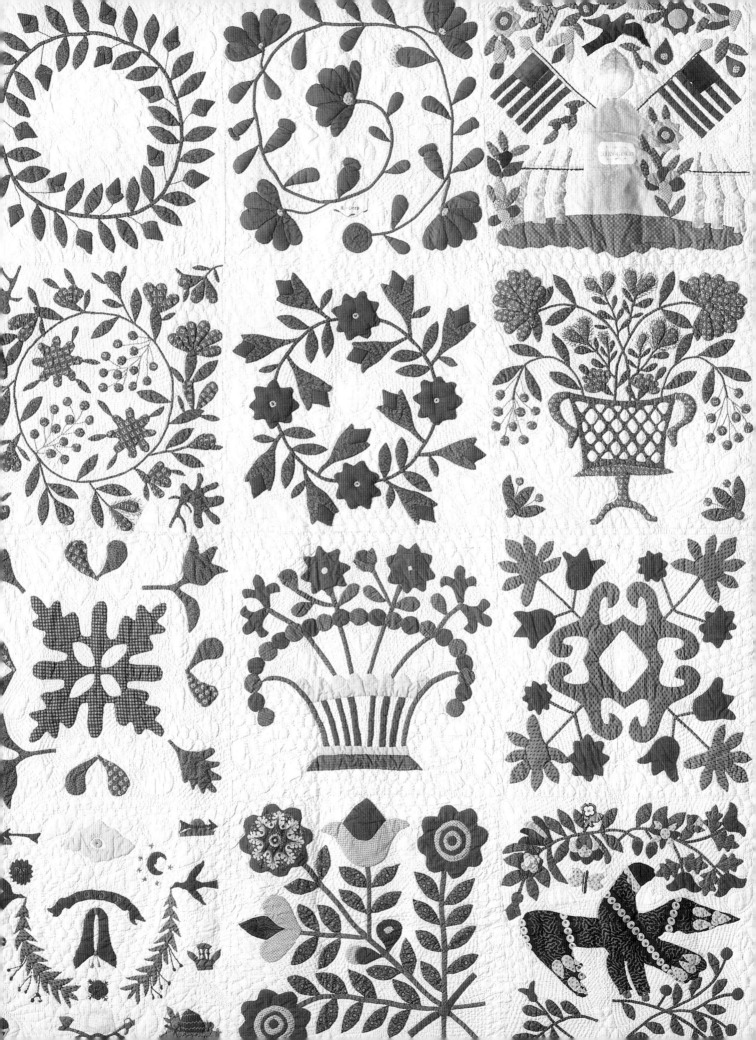